RAGGIN' JAZZIN' ROCKIN'

A History of American Musical Instrument Makers

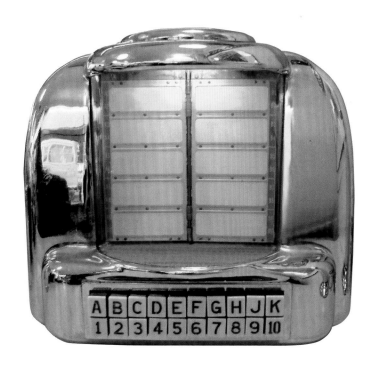

Susan VanHecke

BOYDS MILLS PRESS
HONESDALE, PENNSYLVANIA

*For aspiring musicians everywhere and the educators
who shape, nurture, and challenge them.*
—S.V.

ACKNOWLEDGMENTS

This book would not have been possible without the generous spirit of scores of individuals who gladly shared their expertise, contributed photos and other materials, and vetted the text for accuracy and clarity. These new friends have my deepest gratitude.

I'd especially like to thank Craigie Zildjian, Donna Hobbs, and Chris Frezza at the Avedis Zildjian Company; Leo Spellman and Loretta Russo at Steinway & Sons; Dick Boak at C.F. Martin & Co.; Grant Johnston at Conn-Selmer, Inc.; Jim Catalano at Ludwig Drum Co.; Scott May at Hammond-Suzuki USA; Jason Farrell at Fender Musical Instruments Corporation; Mike Adams and Heidi Bucher at Moog Music Inc.; as well as Dr. Margaret Downie Banks at the National Music Museum; Michelle Moog-Koussa at The Bob Moog Foundation; Roger Luther at MoogArchives.com; Andy Youell at www.drumarchive.com; Peggy Hammond; Mark Vail; Richard R. Smith; Nick DeCarlis; Tony Bacon; Rob Cook; and John Cerullo at Hal Leonard Corporation.

Boyds Mills Press, Inc.
815 Church Street
Honesdale, Pennsylvania 18431
Printed in China

VanHecke, Susan.
Raggin', jazzin', rockin' : a history of American musical instrument makers / Susan VanHecke. — 1st ed.
p. cm.
Includes bibliographical references and index.
ISBN 978-1-59078-574-4 (hardcover : alk. paper)
1. Musical instrument makers—United States--Biography. I. Title.
ML3929.V36 2010 784.19092'273—dc22
2010004877

First edition
The text of this book is set in 14-point Minion Pro.

10 9 8 7 6 5 4 3 2 1

CONTENTS

INTRODUCTION

Perhaps you play an instrument in your school band or take lessons at home. Or maybe you enjoy listening to certain artists, collecting their CDs or downloading their songs to your MP3 player.

But have you ever thought about the instruments that make the music you like? Did you know that some of the greatest names in the business of making musical instruments weren't even musicians themselves? What they lacked in musical knowledge, however, they more than made up for in vision, innovation, and determination.

In this book, you'll meet several of these enterprising individuals, from Avedis Zildjian, a Boston candymaker who forever altered the sound of modern music when he risked bringing his family's Turkish cymbal business to America; to Laurens Hammond, inventor of 3-D glasses, whose dream of an easy-play organ in every living room launched the home organ industry; to radio repair expert Leo Fender, whose Telecaster and Stratocaster are among the world's most recognizable electric guitars.

This book also showcases musicians who became successful business people and eventually launched profitable companies. Among them are cornet player C. G. Conn, whose experiments with brass instruments evolved into the best-known band instrument manufacturing company in the world, and William F. Ludwig, the young drummer who, unable to find a drum pedal he liked, designed and mass-produced his own, becoming an industry giant in drum equipment.

Many of these now well-known names came to the United States from other countries. In America, they found new markets for their instruments. Many supported American war efforts, converting their factories for military use or producing instruments for soldiers.

And all have helped to shape American culture through their innovations in making and marketing their products, as well as in the way their instruments have been used by musicians through the decades.

From saucy ragtime to hot jazz, jitterbugging swing to electric rock, these instrument makers have been the movers and shakers of American musical history—keeping us raggin', jazzin', and rockin'!

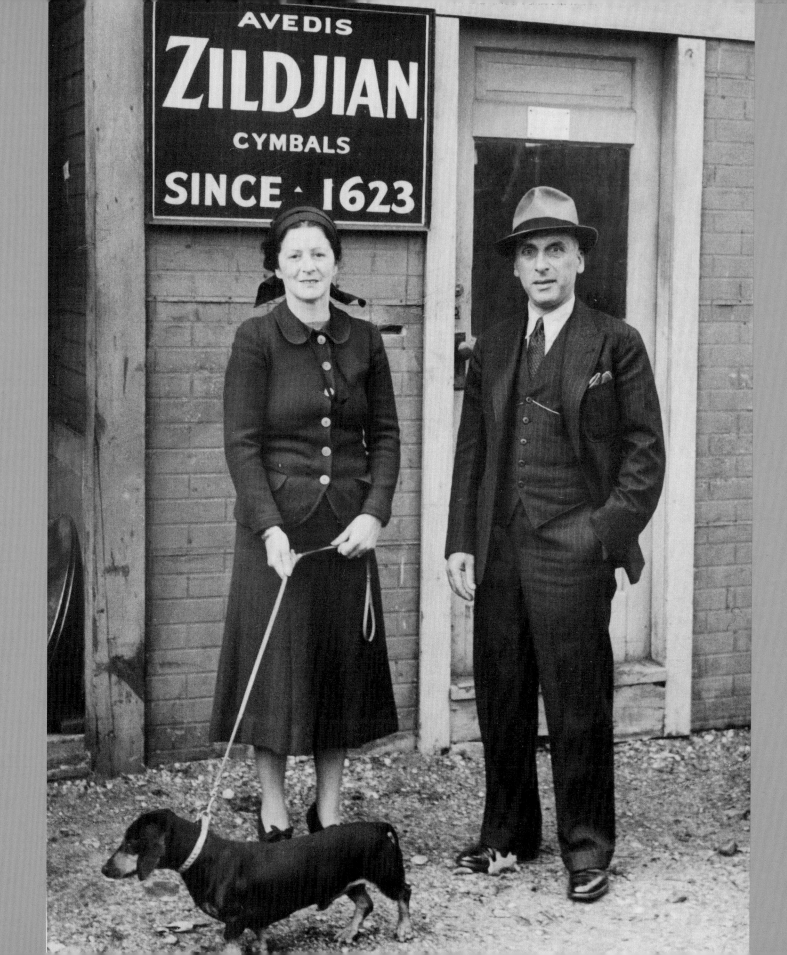

1
Zildjian
Cymbals Through the Centuries

Hᴉs ɴᴀᴍᴇ ᴡᴀs Aᴠᴇᴅɪs, ᴀɴᴅ ʜᴇ ʜᴀᴅ ᴀ ᴅʀᴇᴀᴍ. More than anything else, he wanted to turn common metal into glittering gold.

In 1623, in Constantinople, Turkey, Avedis secretly experimented at the court of the Sultan, where he worked as a metalsmith. He melted tin. He melted copper. He melted traces of silver. He mixed and blended, he poured and cooled. But he didn't make gold. What he came up with was a gleaming sheet of metal that could make musical sounds without shattering—a cymbal.

At that time, loud, crashing cymbals were useful for frightening enemies of the Ottoman Empire, which then ruled Turkey. Mighty Ottoman armies marched into battle to the clashing of cymbals and the beating of drums. Cymbals were also used in the hymns and chants of Armenian and Greek churches. Armenia, where Avedis's family was from, and Greece were also under Ottoman rule.

Avedis's cymbal was exceptionally strong, with a clear, powerful sound. Recognizing Avedis as the founder of Turkish cymbal making, the Sultan awarded him eighty gold pieces. He also gave him a last name, Zilciyan, which means "son of a cymbal maker" or "family of cymbal smiths" in Armenian. In English, the name was spelled Zildjian.

With the Sultan's money, Avedis launched a business making his metal noisemakers. He started a cymbal foundry in Samatya, a suburb of Constantinople, employing his family to help him. For generations, they kept the formula for making cymbals top secret. Only two people knew the process: the head of the company and his eldest son.

In the 1700s and 1800s, as European classical composers began incorporating cymbals into their music, the instrument became an important and permanent part of orchestras. Eager to exploit the growing demand for cymbals, Avedis's descendant, Avedis II, sailed to Europe. There, he displayed his gleaming cymbals at world exhibitions, winning medals in Paris and London for quality and craftsmanship. By the early 1900s, Zildjian was exporting cymbals to Europe and America, where drummers were impressed with their fine, clear sound and unusual strength.

In 1909, Avedis II's grandson, Avedis Zildjian III, immigrated to the United States to escape political unrest in his homeland. He was nineteen

EARLY HISTORY OF THE CYMBAL

A cymbal is a wide, circular plate of metal that makes a sharp, ringing sound when struck. Historians believe that cymbals originated in the ancient region of Anatolia, what is generally present-day Turkey. There, cymbals were used in rituals to worship the goddess Cybele, or Earth Mother, around 1200 BC. Cymbals are often mentioned in the Bible, and they appeared in Babylonian and Assyrian sculpture and in Greek and Roman monuments. Cymbals of various sizes were used in the ancient Far East, from giant temple cymbals nearly three feet across to dainty finger cymbals used by female dancers.

years old. Avedis found a job working in a candy factory in Boston. He quickly learned all he could about candy making, and soon started a candy company of his own.

One day in 1927, a letter arrived for Avedis from his Uncle Aram in Turkey. The time had come for Avedis to take over the family cymbal-making business in Turkey, Aram wrote.

Avedis wasn't sure what to do. He was married now, with children. He was already running his own successful company. He didn't want to return to Turkey. He loved his life in America, where he'd become a citizen in 1916.

Percussionist Frank Epstein of the Boston Symphony Orchestra

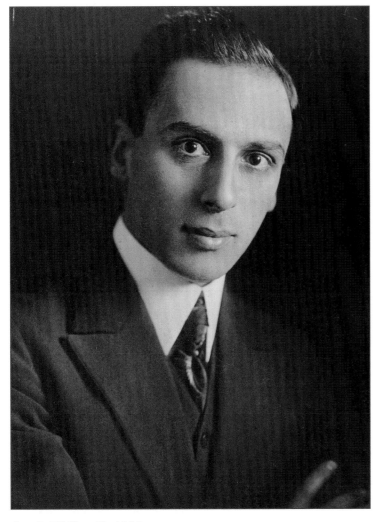

Avedis Zildjian III, 1920

CYMBALS IN CLASSICAL MUSIC

Almost sixty years after Avedis Zildjian made his first cymbal, Nikolas Strungk of Germany may have been the first European composer to use cymbals in his music. They appeared in his 1680 opera Esther. *In the 1700s, composers such as Gluck, Haydn, and Mozart used cymbals in their operas and symphonies.*

Other composers—such as Ludwig van Beethoven, Hector Berlioz, and Richard Wagner—used loud, crashing cymbals to create excitement and drama in their scores. By the end of the 1800s, cymbals were common in classical music.

Aram Zildjian gave his nephew the secret formula for making Zildjian cymbals.

Then Avedis had an idea. Why not move the cymbal company to America? He and his family could make cymbals and stay in the United States.

Aram agreed to the plan. He journeyed to America to teach his nephew the ancient family secrets of cymbal smithing. Together, Avedis and Aram opened a cymbal-making factory outside Boston in a small, one-story building with a dirt floor. The factory was near the ocean so that the cymbals could be tempered, or cooled, with seawater, as they had been in Constantinople. Aram wanted the new factory to resemble the one in Turkey in every way possible. Aram and Avedis named their new enterprise the Avedis Zildjian Company.

Over the next year, Aram taught Avedis all he knew. Avedis memorized the secret formula for mixing the copper, tin, and traces of silver. He learned the family's system for melting the metals into a red-hot pancake in the factory's enormous furnace. He learned how the metal pancake was beaten flat with hammers until the pancake turned into a thin, dark-gray disk.

Avedis watched how the cup was stamped into the center by machine, and how the disk went back into the oven, this time to sweeten the cymbal's tone. He saw how the cymbal was again hammered and its edges trimmed, and how it was then put away to rest for two weeks, a process called *seasoning*. Then he learned how to test the cymbal to make sure it was the finest it could be. From start to finish, each handcrafted cymbal took a month to make.

Opening the new factory was a risky move. In America, there were plenty of drummers using cymbals. They played in symphony orchestras and marching bands, they accompanied vaudeville stage shows and silent movies. But the cymbals they preferred to use were Turkish Zildjians—other family members had reopened the Constantinople factory that Aram had shut down—or fancy cymbals from China. American-made cymbals at the time were of low quality. Not many drummers in the United States wanted another American-made cymbal, even if it had the name Zildjian on it.

To make matters worse, the Great Depression hit only months after Avedis opened the factory in 1929. Now, people were more concerned with feeding their families than going to vaudeville shows, movies, and concerts. And fewer drummers could afford cymbals—even if they wanted them.

But Avedis didn't give up. He worked hard alongside his few employees in

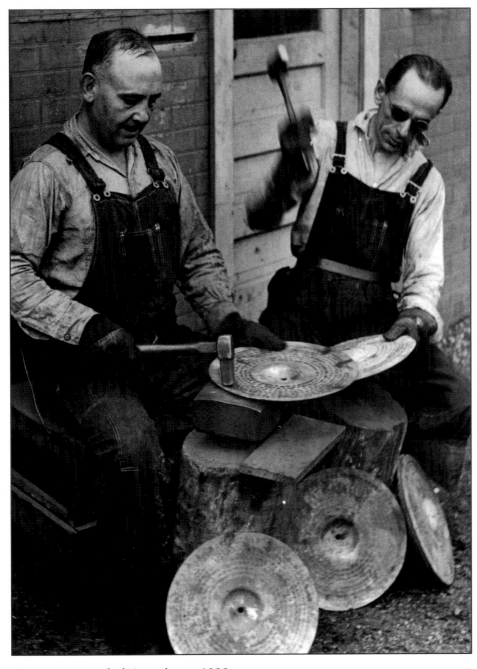

Hammering cymbals into shape, 1930s

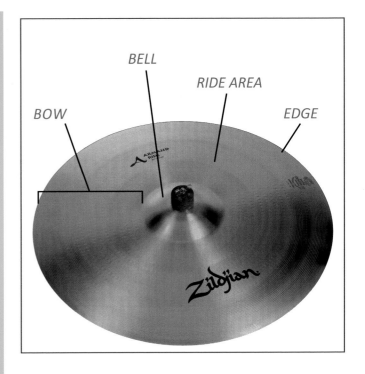

PARTS OF A CYMBAL

BELL or CUP—*The size of the bell or cup largely determines a cymbal's ring. The bigger the bell, the longer and more full-bodied the ring.*

BOW or PROFILE—*The area of curve from the bell to the edge, which determines a cymbal's pitch. The higher the curve—the bow or profile—the higher the pitch.*

EDGE or RIM—*Also known as the "crash area," the edge or rim is where a cymbal responds immediately when struck, making the familiar "crashing" sound.*

RIDE AREA—*Between the bell and edge, the ride area doesn't "crash" when struck, so it is used for distinct stick tones and patterns.*

In the first part of the twentieth century, vaudeville performances and silent movies often shared the stage in theaters across the United States.

Vaudeville shows featured singers, dancers, comedians, and acrobats, all on the same bill.

The first movie was made in 1888. Until sound was added to movies, live music was performed as the silent film played on the screen. Usually a piano, but sometimes an organ or full orchestra, provided the music. The music helped moviegoers understand what was happening in the film.

Movies with sound became popular starting in 1929. They were called "talkies" because moviegoers could finally hear the actors speak.

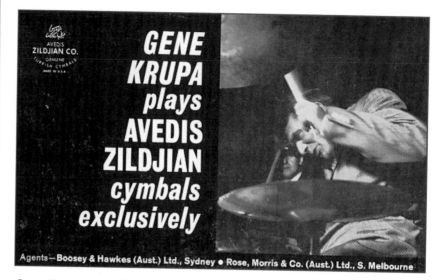

Gene Krupa needed a more nimble cymbal. At his request, Zildjian developed the Paper Thin.

every part of the business. He traveled to large cities, meeting with professional drummers and asking them what they wanted in a cymbal. In New York City, he visited the nightclubs of Harlem, staying up all night talking with jazz drummers. Avedis was a good listener. His drummer friends told him what they liked and disliked about the equipment they used.

While in New York, Avedis met Gene Krupa, drummer for the Benny Goodman Orchestra. The group, led by clarinetist Goodman, was one of the earliest swing bands and among the first to showcase its drummer. Unlike orchestral or military drummers, jazz percussionists played on sets of drums, usually while seated. They used cymbals mounted on stands. Krupa was a wildly entertaining musician, full of rhythmic energy and crowd-pleasing tricks like twirling his drumsticks.

Jazz drummers at that time used traditional marching cymbals, which were big and bulky. One day, Krupa asked Avedis to develop a thinner cymbal, one that would be easier to play, react more quickly, and make its crashing sound faster than a traditional cymbal. Avedis did as Krupa asked, naming his new cymbal the Paper Thin. It was a runaway success; orders poured into Avedis's factory. Now many American drummers demanded American-made Zildjian cymbals.

HARLEM RENAISSANCE

After the Civil War, many African Americans migrated north to bustling urban centers like Chicago and New York City. Now free to express themselves, they created exciting new works of literature, art, music, drama, and dance. New York City's Harlem neighborhood was a hotbed of this creative activity.

On his visits to Harlem, Avedis Zildjian probably stopped by the Cotton Club, the Renaissance Ballroom, and the Savoy Ballroom to hear great jazz musicians of the day.

But while black talents provided the entertainment in these dance halls, black customers weren't always allowed in. The Cotton Club, for example— where black jazz legends Duke Ellington, Cab Calloway, and Louis Armstrong performed—had a "whites only" policy.

As an Armenian raised in Turkey, Avedis knew what it felt like to be discriminated against. The Turks hadn't always treated Armenians kindly. So Avedis reached out to talented drummers, regardless of their color.

Duke Ellington

Cab Calloway

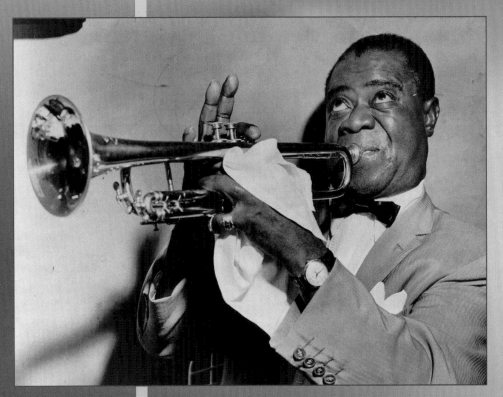

Louis Armstrong

ALL THAT JAZZ

Jazz is an American musical form that began at the dawn of the twentieth century, created primarily by African Americans. The roots of jazz are widespread, and include musical traditions brought to America by enslaved Africans as well as European immigrants:

—the work songs and spirituals of slaves in the Deep South during the eighteenth and nineteenth centuries

—the blues, which also came from the music of slaves, in the late 1800s

—the German waltzes, Irish jigs, French quadrilles, Spanish flamenco, and other musical forms of immigrants arriving in American port cities in the nineteenth century

In the 1890s in Missouri, black pianist and composer Scott Joplin mixed the rhythms of his African American musical heritage with the European-rooted march in a new form called ragtime. Ragtime became a hugely popular type of dance music. Describing the style, Joplin, known as the "King of Ragtime," once said "play slowly until you catch the swing." Ragtime was a precursor to jazz.

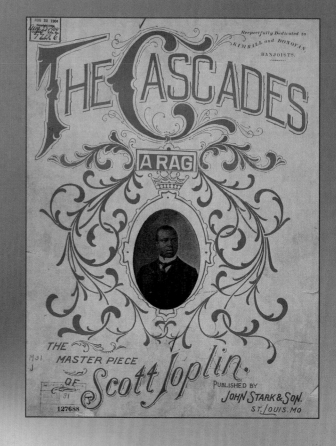

At the turn of the twentieth century in New Orleans, Louisiana, African American musicians blended ragtime and blues with the musical forms of the many Europeans that had settled in the area. The zesty new music they created was called jazz.

As African Americans relocated to northern cities, they brought jazz with them. Young people, especially, liked the fresh, new music. It was lively and spirited and made them want to dance. It wasn't anything like their parents' old-fashioned music. Thanks to young people's radios and record players—available in stores for the first time—jazz spread to America's living rooms and dance halls.

During the Great Depression of the 1930s, most people didn't have enough money to buy jazz records anymore. Instead, they listened to a new form of it—big band swing—on the radio every night. Swing, with its fun, showy arrangements that used many instruments, helped people forget their worries.

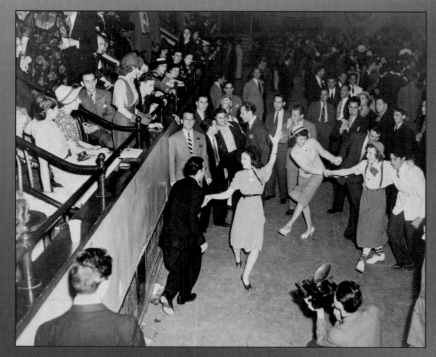

Swing was a popular—and danceable—style of music in the 1930s and 1940s.

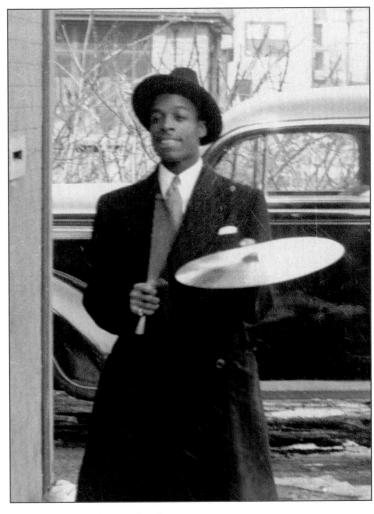

Jo Jones, an artist on the drums

Lionel Hampton, one of the greatest jazz musicians of the twentieth century

As Avedis continued to develop close relationships with drummers, he saw that his friends needed different types of cymbals to make different types of sounds. So he developed a line of special-purpose cymbals. Each could be used in a different way.

The hi-hat, for instance, was paired with another on a pedal-operated stand. The cymbals could be closed for playing lighter, more definite sounds. They could be opened for bigger, louder sounds. Or the drummer could alternate open and closed to play interesting patterns.

Soon, the top drummers of the day were visiting the Zildjian factory in Boston. They would meet with Avedis, who would help them select the right cymbals. Some of the most famous songs of the swing era were

AVEDIS'S SPECIAL CYMBALS

Avedis Zildjian's special-purpose cymbals became basics of modern drumming. Today, most every drummer is at least familiar with these cymbal types, and usually plays some or all of them. Many of Avedis's cymbal models were patented. A patent is a legal protection that keeps others from making the same item in the same way.

SPLASH—A small cymbal whose short crash sounds like a "splash" in water.

RIDE—A cymbal that makes a sustained, shimmering sound that "rides" with the music.

CRASH—Mounted or played in pairs, crash cymbals produce a loud, sharp, crashing sound.

HI-HAT—A pair of cymbals mounted on a stand that can be played while open or closed together, as in picture below.

SIZZLE—A cymbal with rivets, chains, or rattles attached to it to create a sizzling sound.

Armand Zildjian, the most musical of all the Zildjians, met with the great drummers of the time to create the types of cymbals that they wanted.

recorded with Zildjian cymbals, such as Tommy Dorsey's "Marie," with Davey Tough on drums; Benny Goodman's "Sing, Sing, Sing," with Gene Krupa; and Don Redman's "Stormy Weather," with "Big" Sid Catlett.

Avedis and Sally's oldest son, Armand, was very excited to meet the famous drummers. He talked to them, saw them play, and watched them test the cymbals. As Avedis's oldest son, Armand knew the secret Zildjian family cymbal-making process by the time he was fourteen.

During World War II, metals were rationed. Most metal went to making airplanes, tanks, and weapons. The U.S. government allowed the Zildjian company only small amounts of copper and tin. It wasn't enough to make cymbals for sale. But instead of closing down the factory, Avedis made cymbals for the Army, Navy, and Marine Corps marching bands. He made cymbals for the British military, too. As an American citizen, Avedis was proud to help his country in the war effort.

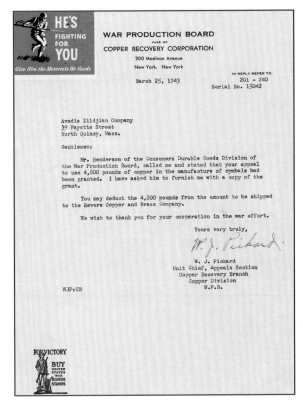

Though metals were rationed during World War II, the U.S. government gave Zildjian permission to use copper for making cymbals.

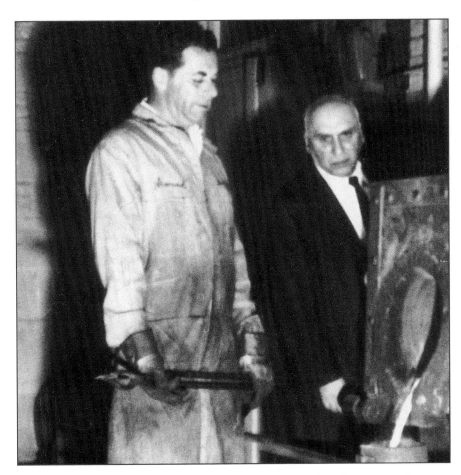

Armand and his father, Avedis, pouring molten metal in the Zildjian factory

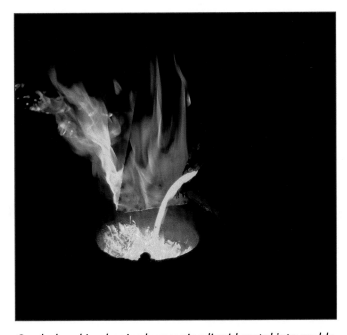

Cymbal making begins by pouring liquid metal into molds, a process that dates back centuries.

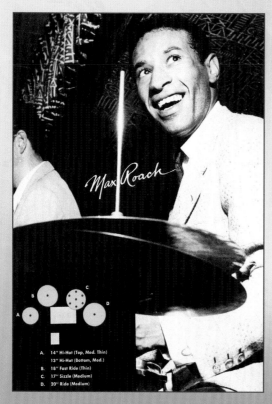

Max Roach, a pioneer of bebop

ALL THAT JAZZ, AGAIN

Big band swing of the 1930s gave way to a more complicated, less danceable form of jazz called bebop in the 1940s. Bebop's sound was challenging, with unusual chord changes and unpredictable rhythms. Toward the end of the '40s and into the 1950s, cool jazz gave bebop a lighter, more accessible sound.

Through the 1960s and '70s, jazz fusion developed. A mix of jazz and rock styles, jazz fusion used electric instruments, such as guitar, bass, piano, and synthesizer keyboards.

Smooth jazz, which emerged in the 1980s, offered an easy-listening sound, blending bits of jazz, rhythm and blues, funk, and pop. Urban jazz is a new hybrid that mixes jazz with elements of hip-hop.

Because of the development of other musical styles like rock and rap, jazz is not nearly as popular as it once was. However, all forms of jazz are still performed by musicians across the world today.

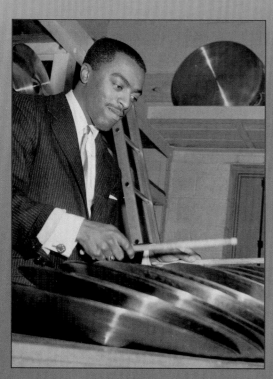

Roy Haynes, one of the most popular modern jazz drummers

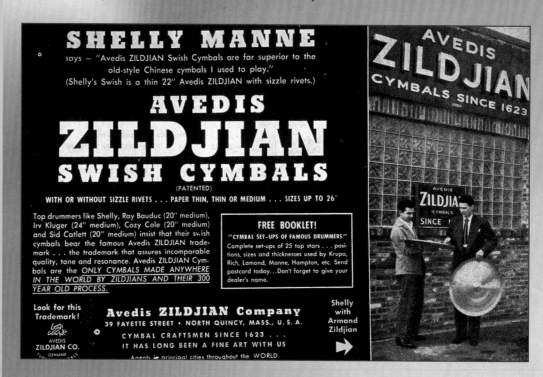

In the 1950s, black and white musicians in the United States blended elements of rhythm and blues and country and western music to create rock and roll. Like jazz before it, the explosive new sound of rock and roll appealed to young people, who listened to it on their radios and record players and on jukeboxes. Recordings by artists such as Bill Haley and his Comets, Elvis Presley, Little Richard, Chuck Berry, Jerry Lee Lewis, and Fats Domino were popular across the country, and, soon, around the world.

In the 1960s, musicians in England reinterpreted the American rock and roll sound. Music by groups such as the Beatles, Rolling Stones, the Who, and the Dave Clark Five became enormously popular in the United States. This musical phenomenon was called the British Invasion.

In the late 1960s and into the '70s, rock and roll gave way to rock, with a louder, more distorted electric guitar sound at its core. Some musicians experimented with rock, mixing it with country to create country rock or with rhythm and blues to create funk. Other musicians added new technology, like super-high amplification to create heavy metal or electronic keyboards to create electronica.

Often, rock music is used to express its makers' ideas about how society works or doesn't work, as in folk rock, punk rock, or grunge rock. Like jazz, rock music continues to evolve.

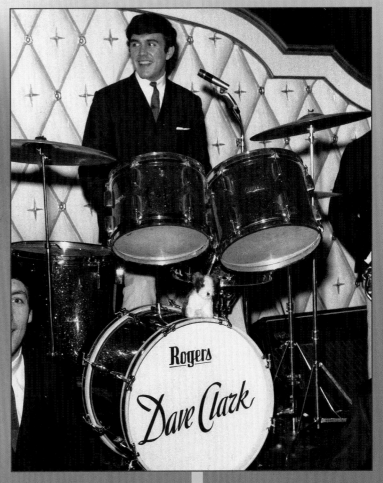

Dave Clark of the Dave Clark Five, among the bands of the "British Invasion"

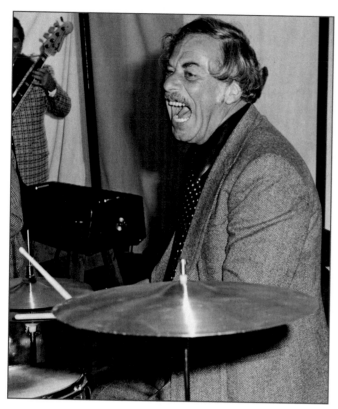

Armand Zildjian at the drums

While Avedis's sons were off fighting in the war, he finally wrote down the family's secret cymbal-making process. It was the first time that had been done. He put one copy of the formula in the company vault and another in his home in case his sons didn't return.

When the war was over, Avedis's sons did come home. Avedis gave responsibility for the manufacturing side of the business to Armand, the most musical of all the Zildjians.

Following his father's lead, Armand developed friendships with top drummers of modern jazz of the 1950s, such as Max Roach, Shelly Manne, and Roy Haynes. Like his father before him, Armand introduced different types of cymbals, expanding Zildjian's product line and reputation as the world's finest cymbal manufacturer.

When a new British rock band, the Beatles, appeared on American television in 1964, its drummer, Ringo Starr, played Zildjian cymbals. Demand exploded. Zildjian ended the year with back orders for more than ninety thousand cymbals. As rock music evolved and developed, so did the Zildjian cymbal design. Larger, heavier cymbals with deeper cups allowed rock drummers to be heard over the amplified guitars and vocals.

In 1977, Avedis named Armand president of the company. Avedis died two years later, but the Avedis Zildjian Company continued to grow, operating on its founder's beliefs of developing personal relationships with customers, pioneering important new products, and making the finest cymbals possible.

Today, Craigie Zildjian, Armand's daughter and Avedis's granddaughter, runs the Avedis Zildjian Company. Avedis asked her to join in 1976, breaking the three-hundred-fifty-year-old tradition of males only in the upper ranks at Zildjian.

Despite the many changes in cymbal-making technology, cymbal design, and company leadership, one thing has remained the same over the centuries at Zildjian: the unique sound of its cymbals. As Armand, who passed away in 2002, once said, "A Zildjian cymbal just zings."

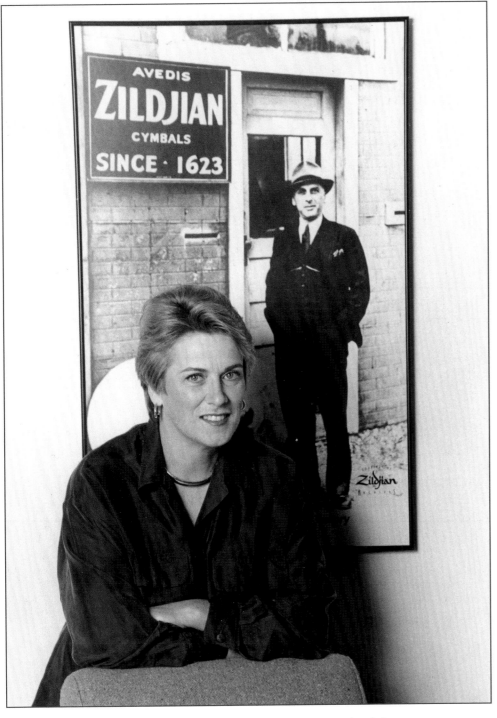

Craigie Zildjian, Avedis's granddaughter, the first woman to lead the Avedis Zildjian Company

"A Zildjian cymbal just zings."
—*Armand Zildjian*

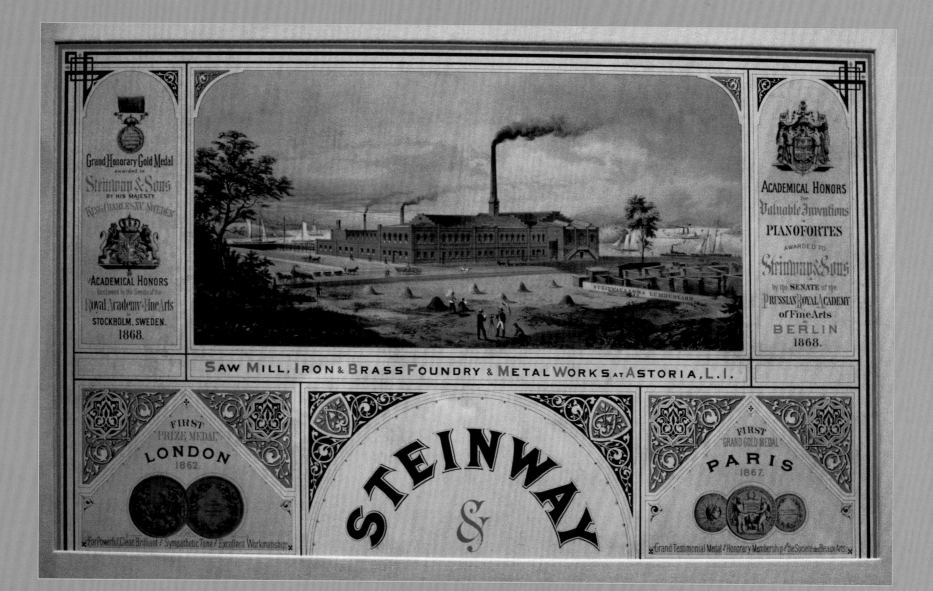

2

Steinway & Sons
Instrument of the Immortals

It WAS A DAY OF CELEBRATION IN THE TINY mountain village of Seesen, Germany. The year was 1825, and young Heinrich Engelhard Steinweg was marrying his true love. Heinrich worked in the shop of an organ builder in Seesen. He also played the organ at the local church. His bride, Julianne Thiemer, was the daughter of a wealthy glove maker.

Julianne was the woman of Heinrich's heart. She even pumped the organ bellows for him as he played at their wedding ceremony. Heinrich's wedding present to Julianne was a finely crafted piano—the first he'd ever built with his own hands.

Heinrich could not know it then, but his pianos would eventually become known as the best in the world.

Julianne's piano, or pianoforte as it was called at the time, wasn't the first instrument Heinrich had made. While serving in the army as a teen, he assembled a cithara—a stringed instrument similar to a zither—during his free time. He played it for his fellow soldiers, who were impressed with his musical skill.

◀ *A nineteenth-century promotional card shows the enormous Steinway & Sons factory as well as various awards*

Harpsichord

EARLY HISTORY OF THE PIANO

A piano is a stringed keyboard instrument in which each key operates a felt-covered hammer that strikes a wire or wires to create sound.

The first instrument generally considered to be a piano is the arpicembalo che a il piano e il forte, *Italian for "harpsichord that can play quietly and loudly." It was a harpsichord modified by Bartolomeo Cristofori. Cristofori worked in the court of a prince in Florence, Italy, in the late seventeenth and early eighteenth centuries.*

The harpsichord was a stringed instrument that looked much like our modern piano, except its metal strings were plucked with quills. No matter how hard one pressed a harpsichord's keys, it played at only one volume.

Cristofori invented a mechanism that used a hammer to strike, not pluck, the strings with variable force. The force depended upon the pressure placed on the keys by the musician's fingers. This new instrument could be played softly—piano in Italian—or loudly—forte. Through the centuries, Cristofori's new instrument came to be called the fortepiano *or* pianoforte, *then, simply, the* piano.

After marrying Julianne, Heinrich opened his own organ-making business. Soon he was able to move his family, which would grow to include three daughters and six sons, into a two-story house with a workshop, cellar, and garden. Heinrich still constructed pianos—at home in the kitchen, according to family lore. In 1835, he started a piano business.

Soon Heinrich brought three of his homemade pianos to an exhibition in nearby Brunswick. His fourteen-year-old son, Theodore, played the pianos there. People liked the way Heinrich's pianos looked and sounded. Heinrich won a gold medal for his pianos' superb workmanship and tone.

As Heinrich's reputation as a master piano builder grew, his sons Theodore, Charles, and Henry joined him in the business. When political upheaval gripped Germany in the late 1840s, Heinrich and Julianne sent Charles to the United States. They asked him to find a safer place for the family to live and build their instruments. Along with many other German immigrants, Charles landed in New York City in 1849. He quickly found a job at one of the many piano makers in town. Then he wrote to his family, urging them to join him in this land of opportunity.

Heinrich and Julianne sold their house, gathered up their children, and set sail for America. Theodore stayed in Germany, repairing violins, tuning pianos, and experimenting with piano designs. The Steinwegs landed in New York in 1850, where they found a large community of German

Original Steinway piano, 1839

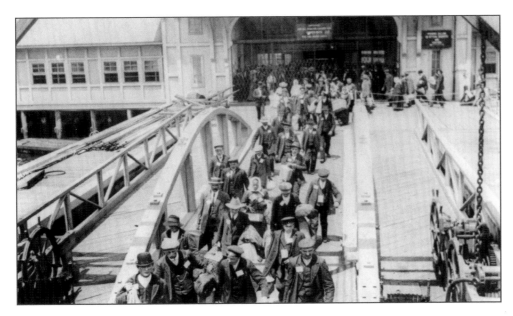

Immigrants brought their music to America.

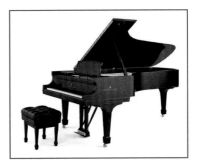

GRAND
The strings run horizontally in a grand piano. A grand piano, even a "baby grand," is a very large instrument. In concert events, grand pianos are almost always used because of their full, loud sound.

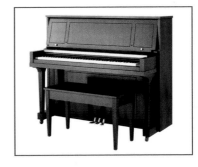

UPRIGHT
The strings run vertically in an upright piano, also called a vertical. An upright takes less floor space than a grand.

SQUARE
The strings run horizontally, but are arranged diagonally, in a square piano. A square piano is actually rectangular. The upright eventually took the place of the square as an alternative to the large grand piano.

immigrants. These Germans brought their rich musical traditions to America. They formed choirs and orchestras to perform classical music in their new homeland.

Heinrich and his sons found jobs in different piano factories in New York City. Working for others, the Steinwegs learned the language and business methods of American piano makers. After three years, the Steinwegs were ready to launch their own piano-making business. Changing their name to the more American-sounding "Steinway," in 1853 the men formed a partnership. The piano-making company of Steinway & Sons was born.

The Steinways set up shop on Varick Street, in lower Manhattan. The first piano made by Steinway & Sons was given the number 483. Why 483? Heinrich had built 482 pianos before founding the company. Number 483 was sold to a New York family for $500. Today the piano is part of the collection at the Metropolitan Museum of Art.

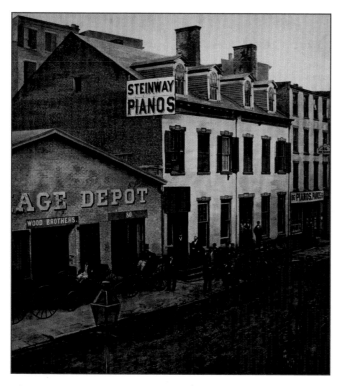
The Walker Street factory in the heart of New York City's "piano row" district, ca. 1854

Their first year in business, the Steinways sold eleven pianos, all of them square. Most pianos made in the United States at that time were square. In 1854, the firm moved to a larger space nearby on Walker Street. It was in the heart of "piano row," the area of the city where most piano manufacturers were located. The family proudly painted a "Steinway Pianos" sign on the side of the building.

The mid-nineteenth century was a good time to start a piano business. The piano was the main source of music in the home. There were no radios, televisions, or record players. And a piano in the parlor was a symbol of wealth and respectability.

The Steinways worked hard—all of them. Even the women were involved in the business, which was unusual for the time. Julianne handled all of the company's correspondence. Julianne and Heinrich's daughter Doretta sold pianos in the showroom. Sometimes she threw in free piano lessons to close a sale.

Doretta Steinway sold pianos and gave music lessons.

Soon the Steinways began to exhibit their pianos at trade fairs, just as Heinrich and Theodore had done in Germany. In 1854 in Washington, D.C., the new company won a prize medal for its square piano. The following year, at an exhibition in New York City, they created a sensation with a new piano designed by Henry. It sounded like no other piano of its day, with its powerful tone and rich, brilliant sound.

Sales of Steinway pianos multiplied. It was soon clear that the company needed a larger factory to keep up with demand. In 1858, the Steinways purchased land uptown on what was then called Fourth Avenue, today known as Park Avenue. Heinrich supervised the construction of the mammoth Steinway factory. The new building had four kilns to dry lumber, four elevators to haul pianos from floor to floor, and scores of saws, lathes, planes, and other equipment. Hundreds of men—many of them immigrants from Germany, Ireland, England, and Sweden—worked at the new factory.

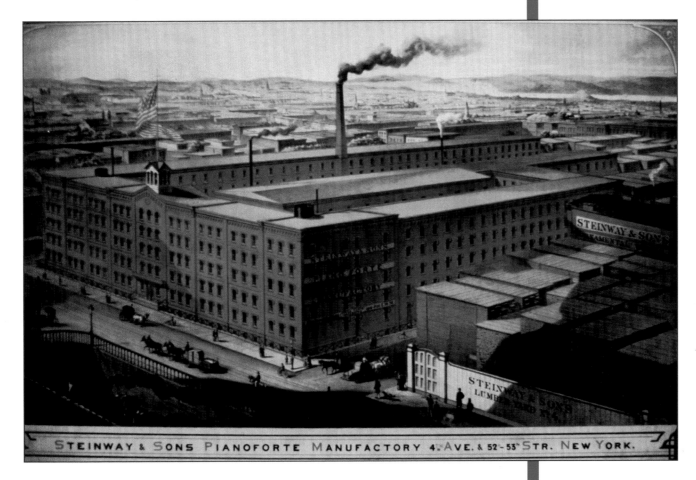

STEINWAY & SONS PIANOFORTE MANUFACTORY 4ᵗʰ AVE. & 52ᵗʰ-53ʳᵈ STR. NEW YORK.

Demand for Steinway pianos was so great that a huge factory was built uptown on Fourth Avenue, now known as Park Avenue. (ca. 1860s)

Stringing a piano

PARTS OF A PIANO

CASE—The wooden cabinet that houses all the parts of the piano. At Steinway & Sons, the case is formed using a rim press, large clamps, and strong men to bend the wood into the familiar piano shape.

PLATE—The cast iron frame that holds the strings, also known as the harp.

STRINGS—The strands of steel stretched across the plate that vibrate when struck by the piano's hammers. There are more than two hundred strings in a piano.

SOUNDBOARD—The large, thin piece of wood under the strings. The soundboard amplifies, or makes louder, the sound of the vibrating strings.

BRIDGE—The curved strip of wood that transmits the strings' vibrations to the soundboard.

KEYBOARD—The black and white keys. Most modern pianos have eighty-eight keys—fifty-two white and thirty-six black.

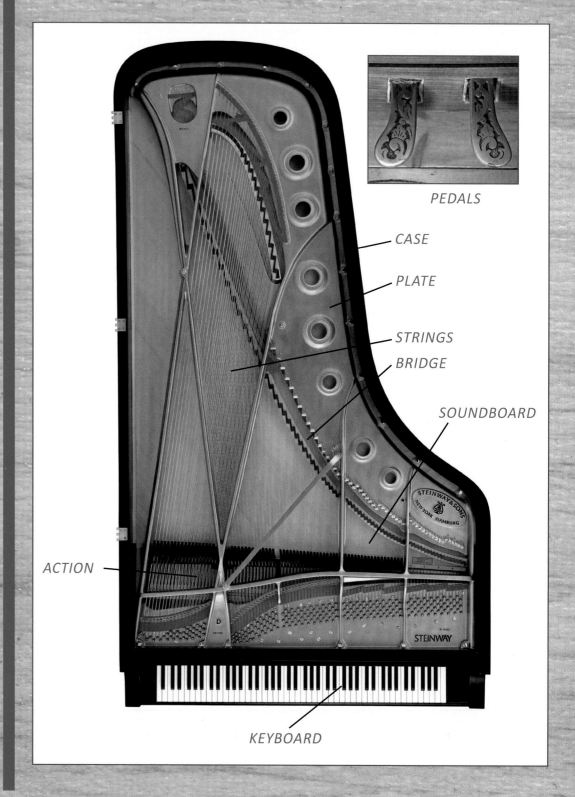

PEDALS

CASE

PLATE

STRINGS

BRIDGE

SOUNDBOARD

ACTION

KEYBOARD

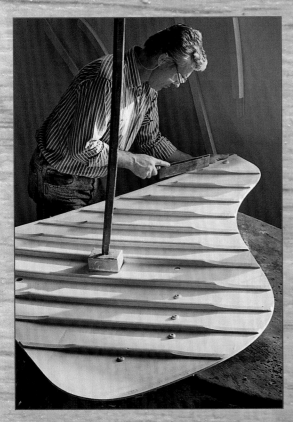

Creating a soundboard

Henry continued to experiment with new designs. He placed the piano strings in different positions. He made improvements to the iron plate, which holds the strings. He fine-tuned the "action," how the pressing of a key causes a hammer to strike the string, which produces a piano's sound.

Henry's modifications made Steinway pianos louder, with a richer tone. This was important because concert halls were becoming bigger, seating thousands of people instead of hundreds. A louder piano could be heard from every seat. Henry's pianos were more responsive, too, so that a pianist could play more expressively. The musician could press a key in quick repetition, loudly or softly, and the string would still sound. With most other pianos, a pianist would have to wait for the key to return to its original position before pressing it again. Henry's improvements were called the Steinway system. They were so important that all pianos today use them.

Henry knew that he had created the finest piano ever made. Now he needed to persuade the public. But how? At the time, it was thought that the best pianos came only from Europe. Henry decided that Steinway & Sons needed to win a gold medal from a prestigious European exhibition. So, in 1862, Henry shipped two square pianos and two grands to London's Great International Exhibition. More than six million people attended. Steinway did, indeed, earn a medal for "powerful, clear, brilliant, and sympathetic tone, with excellence of workmanship." European piano makers, long considered superior to American piano makers, came away from the exhibition stunned at Steinway's innovations. Steinway was fast becoming the standard by which all pianos would be measured.

Steinway took first prize at London's Great International Exhibit, 1862.

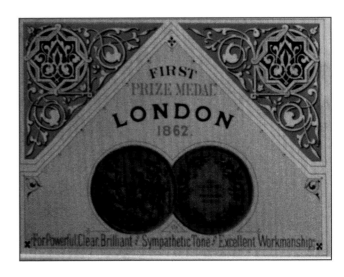

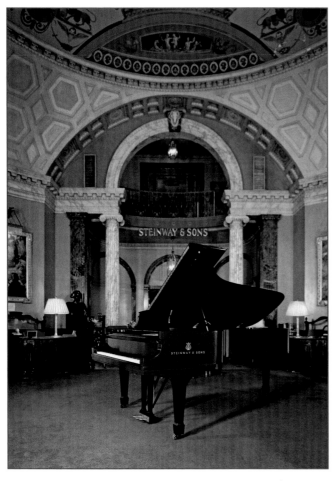

Steinway Hall, today, with the showroom on 57th Street

culture, style, and good taste. If he could get famous pianists of the day to play Steinway pianos, William thought, the pianists' audiences would want to own and play Steinways, too. So in 1872, a year after Heinrich's death, Steinway & Sons sponsored Anton Rubinstein's first and only concert tour of the United States.

Rubinstein was a superstar in Europe. William guaranteed Rubinstein $40,000 for 215 concerts across the country. It was a large sum of money, equivalent to about $725,000 today. The concerts were to be played, of course, only on Steinway pianos.

American audiences rushed to see Rubinstein perform great classical works by Bach, Beethoven, and Chopin. Thanks to Steinway & Sons, the famed Rubinstein performed in big cities and small towns across America for nearly a year. In this way, Steinway brought live classical music to many people who otherwise would not have access to it. Over the years, the Steinway company would connect with other great musicians, such as Ignacy Jan Paderewski, Vladimir Horowitz, and Van Cliburn.

As Steinway & Sons grew, William decided he needed to expand his operation. He didn't have to look far. Four miles from his Manhattan factory, across the East River in the borough of Queens, sat hundreds of acres of open space in an area called Astoria. William thought Astoria was the ideal location for his big idea: an enormous factory surrounded by a village where Steinway workers would live.

So, on the four hundred acres he'd purchased, William built a sawmill, iron and brass foundries, a steam-engine house, and a huge building for drilling and finishing. He installed a private telegraph line to the Manhattan factory and Steinway Hall.

Near the new factory, William built houses. He funded a church, school, and library. He paid to have streets and sidewalks paved and hundreds of trees planted. He set up the Steinway Railway Company and purchased most of the trolley lines in western Queens, electrifying them with power from his factory.

William also built the largest amusement park and bathing beach in New York City on what is now the site of LaGuardia Airport.

With the Steinway name now firmly a part of American musical life, William again set his sights across the Atlantic. In 1875, Steinway opened a store in London. Three years later, a Steinway Hall in London opened its doors, with seating for four hundred.

LEGENDARY STEINWAY ARTISTS

ANTON RUBINSTEIN — Born in Russia in 1829, Anton Rubinstein learned to play the piano at age five. By the time he was seventeen, he had performed throughout Europe.

GEORGE GERSHWIN — Born in Brooklyn, New York, in 1898, Gershwin became a major force on Broadway. He is best known for his orchestral compositions Rhapsody in Blue *and* An American in Paris, *and the many songs he wrote, including "I Got Rhythm" and "Summertime," still popular today.*

IGNACY JAN PADEREWSKI — Paderewski was born in Russian-occupied Poland in 1860. In 1919, he became the prime minister of the newly independent Poland. Paderewski is unique in that he was both a great musician and politician.

VAN CLIBURN — Cliburn was born in Louisiana in 1934, but moved to Texas when he was six. In 1958, Cliburn played in the International Tchaikovsky Piano Competition in Moscow, Russia, where he won the gold medal, a great honor for such a young man and an American.

VLADIMIR HOROWITZ — Another Russian pianist, born in 1903, Horowitz's style was showy and dramatic. His first performance in the United States was at New York City's Carnegie Hall in 1928.

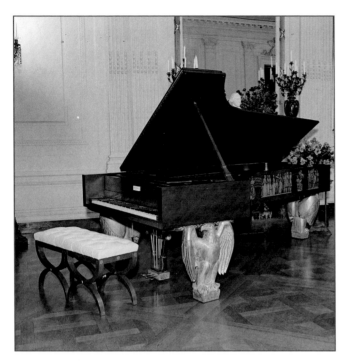

In 1938, Steinway and Sons presented this special grand piano to President Franklin D. Roosevelt.

In 1880, Steinway factories began production in Hamburg, Germany. Theodore, who never really liked New York City, happily returned to Germany to oversee the business. He died in 1889. With his younger brother, Albert, also gone—he'd died of typhoid fever in 1877—William looked to the next generation of Steinways for a business partner. His nephews Charles and Fred, sons of William's late brother Charles, took on the responsibility.

When William Steinway suddenly died of typhoid fever in 1896, the mayor of New York City ordered that flags on all city buildings be flown at half-mast. William had done great things for the city of New York, as well as the Steinway company.

The Steinway & Sons business remained strong under the guidance of Charles, Fred, and their cousin Henry Zeigler, Doretta's son.

In 1902, to celebrate production of its one-hundred-thousandth instrument, the Steinways crafted a very special piano. It was gilded with gold leaf, with an elaborate painting on the lid. The piano was presented to President Theodore Roosevelt, who placed it in the East Room of the White House. Thirty-six years later, to celebrate its three-hundred-thousandth piano, Steinway & Sons presented President Franklin D. Roosevelt with a special grand.

By 1909, player pianos had become popular. A player piano didn't require a person to play it. A mechanical device inside the piano did all the work. After long promoting itself as the piano of concert pianists, should Steinway add a player piano to its product line? Charles, president of the company, decided it should. For the next twenty-five years, music lovers could purchase a Steinway piano that they didn't even need to know how to play.

In the summer of 1914, war broke out across Europe. Three years later, after German submarines sank American merchant ships, the United States entered the conflict, called World War I. With factories in both Germany and America, Steinway & Sons was caught in the middle. Business at the Hamburg factory was all but shut down. Business at the New York factory, however, was brisk, as wartime industry brought prosperity to the United States. The war also brought a big change to the Steinway operation. For the first time, women worked in the factory. They replaced the men who had gone off to fight in Europe. Some women were even promoted to management positions.

By 1919, the war had ended and men had returned to the Steinway factory. But New York City was in the grips of a flu epidemic that killed thousands. One of those who died was Charles Steinway. After his death, the family promoted Fred to the position of president at Steinway & Sons. Henry Zeigler became vice-president.

One of Fred's most important business decisions was to invest in distinctive new advertising. Raymond Rubicam, a young writer with N. W. Ayer & Son, the Steinway advertising agency, came up with an idea. Instead of ads showing lovely ladies sitting at Steinway pianos in their living rooms, why not show famous concert pianists at their Steinways? After all, Rubicam thought, Steinways had been used by many of the world's greatest pianists and composers. The memorable phrase "The Instrument of the Immortals" formed in his mind. Using beautiful oil paintings by famous artists, the new "Immortals" advertisements were a hit.

Player pianos use a perforated roll of paper that passes over a special bar. The bar also has holes in it, which correspond to the keys of the piano. When the holes in the paper and the bar line up, a suction mechanism draws air through the holes. This activates the hammer to strike the strings.

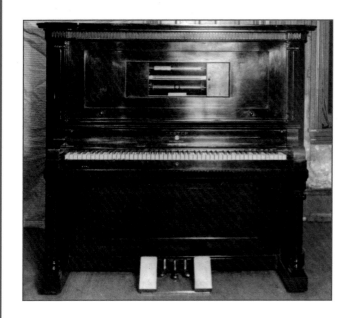

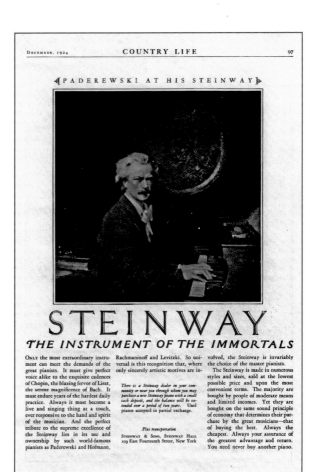

Steinway ads featured the great pianists of the day, such as Paderewski. (Country Life magazine, 1924)

Theodore E. Steinway guided the company through the Great Depression.

When Fred Steinway died of a heart attack in 1927, his cousin, Theodore E. Steinway, William's youngest son, was appointed president.

Theodore took charge of Steinway & Sons just as it was entering some of its most difficult years. Radio, movies, and the phonograph were replacing the piano as a source of entertainment. The Great Depression of the early 1930s reduced Steinway's sales even more. Things got so bad that Theodore had to close the American factory until the economy recovered.

Swing, the lively jazz style people now enjoyed on their radios, launched a new interest in music in the late 1930s. Tired of worrying about making ends meet, people wanted to listen to music that was fun. And they wanted to make their own fun music. So piano manufacturers introduced less expensive, smaller instruments: upright pianos called spinets. Many people bought the more affordable spinets.

The words *less expensive* and *small* had never applied to Steinway pianos. Hungry for sales, though, Steinway responded to this latest trend. In 1936, the company rolled out a new model, a baby grand. It was a smaller instrument but had the sound of a larger grand piano. In

Baby grand

1937, Steinway introduced its own version of a spinet, which it called a Pianino.

Despite the new products, the company's sales remained sluggish. To make matters worse, piano makers had to compete with a new keyboard instrument. In 1935, a clockmaker from Chicago named Laurens Hammond introduced an electronic organ. Though it sounded like a pipe organ one might hear in a church, it had no pipes. And it was roughly the size of a large upright piano. Now every family could have the sound of a fancy pipe organ in the comfort of their own living room.

As Steinway & Sons hobbled out of the Depression years, things changed again with World War II. Women were back in the factory, their husbands, sons, and brothers off to the front lines in Europe. And Steinway in America now made aircraft instead of pianos.

How did Steinway go from making pianos to airplanes? In America, metal was rationed because of the war. It had become almost impossible for the company to produce pianos, with their iron frames and steel and copper strings. Steinway & Sons, with its woodworking experts, was hired to make parts for wooden gliders instead. The gliders were used by the U.S. military to transport soldiers and supplies behind enemy lines.

While Steinway & Sons in America was assisting the U.S. military and its allies, Steinway in Germany was forced to help the U.S.'s enemy, the Nazis. Because the factory in Hamburg was owned by Americans, the Nazi government declared it enemy property. With the wood normally used for crafting pianos, the Nazis ordered that the factory produce decoy airplanes, beds for air raid shelters, and rifle stocks.

The war years were difficult for the Steinways. In America, Theodore's four sons were now in the military, doing their duty for their country. But because of the family's German heritage, the Steinways were suspected of being Nazi informants. In Germany, bombing leveled the Steinway administrative offices and severely damaged the factory.

Happily, all of Theodore's sons returned safely from the war. The second oldest, Henry, went to work at the family firm. He had a good head for business and, in 1955, replaced his father as president. The great-grandson of Heinrich Englehard Steinweg, Henry would be the last Steinway to run the family business.

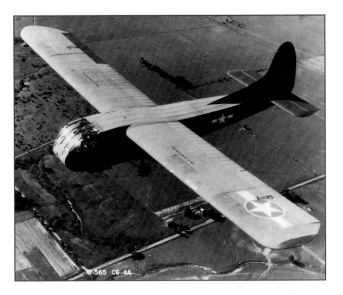

STEINWAY'S GLIDER

The CG-4A glider was a large, engineless aircraft. It could carry more than a dozen soldiers. The gliders were towed though the air by airplanes, then let loose to silently glide into enemy territory.

VICTORY VERTICAL

During World War II, specially designed pianos called Victory Verticals were dropped by parachute to bring music to the soldiers on the ground.

Today, Steinway & Sons crafts nearly four thousand pianos a year in its New York and Hamburg factories. In America, more than five hundred people are involved in the process of crafting a single piano, which can take up to a year. And even though the company is no longer in family hands, the Steinway reputation for quality lives on, more than one hundred and fifty years after Papa Heinrich and his boys founded Steinway & Sons.

Henry Steinway, the great-grandson of Heinrich Englehard Steinweg and the last family member to run Steinway and Sons

The 500,000ᵗʰ Steinway piano, 1987

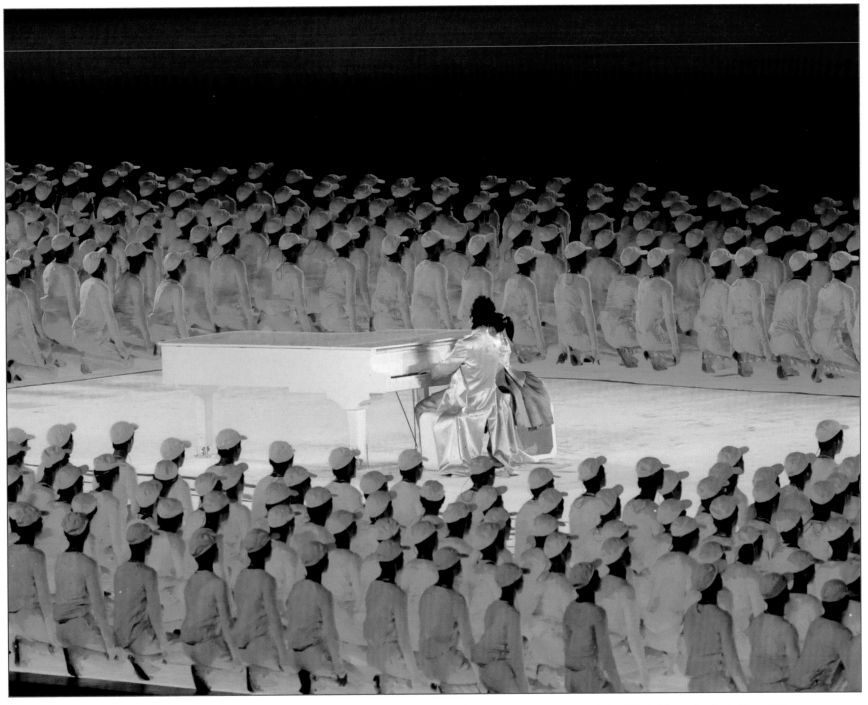

Steinway in the twenty-first century: A Steinway grand piano is center stage in the opening ceremony of the 2008 Olympics in Beijing, China.

PERFECTED CONN-QUEROR CORNET.

WONDERPHONE CORNET.

PERFECTED WONDER CORNET.

3

C. G. Conn
Strike Up the Band!

IT WAS 1874 AND, ACCORDING TO LEGEND, Charles Gerard Conn of Elkhart, Indiana, had a big problem.

Gerard, as he was called, loved to play the cornet, a brass horn similar to a trumpet. He'd learned to play the instrument as a boy. After he'd run off at age seventeen to fight in the Civil War, he became a cornetist in the Union army. After the war, he'd played the cornet while leading a community band in Elkhart.

But now Gerard could hardly play at all, the story goes. Someone had punched him in the face and split his lip. With his injury, there seemed no way Gerard could blow properly into his cornet's mouthpiece. It was simply too painful.

Gerard was determined to play the cornet again, despite his damaged lip. One day he had an idea. What if he coated his cornet's mouthpiece with rubber? Rubber was soft and flexible. Gerard gave it a try. To his delight, it worked. With his new rubber-cushioned mouthpiece, Gerard could comfortably blow his horn once more.

Whether the split-lip legend, or parts of it, is actually true remains in dispute. But it's no tall tale that it was Gerard's rubber-rimmed mouthpiece that launched the C. G. Conn Company, the oldest continuous manufacturer of band instruments in America.

◀ *Early models of cornets produced by the C. G. Conn Company*

The rubber-rimmed mouthpiece launched the C. G. Conn Company.

WHAT IS A KEY?

In music, a key is the major or minor scale on which a song is based. Most music is built upon the major scale. The major scale contains seven notes. Have you ever heard someone sing the familiar "do-re-mi-fa-so-la-ti"? That is the major scale. The first note, the do, is called the root. The letter name of the root determines the name of the scale. So a song played in the key of C major is a song built around the C major scale.

Some instruments play in a certain key. For instance, the common cornet plays in the key of B-flat. This means that when a cornetist plays a C major scale from a piece of sheet music, the notes we hear are actually the B-flat major scale. When writing music, especially for groups, composers have to take the various keys of instruments into consideration.

Soon, other musicians wanted Gerard's special mouthpiece. He made a few for friends. As demand grew, he turned an old sewing machine into a lathe, a machine that spins a block of material, such as wood or rubber. The material can then be shaped by holding a cutting tool against it as it spins. With his makeshift lathe, Gerard turned out his special mouthpieces as fast as he could.

By 1875, Gerard was also crafting silver-plated brass mouthpieces in his own small shop and brass foundry. But Gerard had grander visions. He wanted to create the perfect cornet.

The typical cornet played in only one key, B-flat. Gerard thought a horn that could play in more than one key, at both high and low pitches, would be a much more versatile instrument. So Gerard invited French instrument maker Eugene Victor Jean Baptiste Dupont to join him in Elkhart. They formed a partnership, called Conn-Dupont, to produce the Four-in-One cornet. This new horn played in four different keys —E-flat, C, B-flat, and A.

By mid-1880, Conn and Dupont had dissolved their partnership. Gerard took over the entire business, including the large factory in Elkhart he'd purchased in 1878. Located next to the Elkhart River, the three-story facility was run by hydraulic, or water, power. Close to a hundred men worked at the factory. With the all-brass band an important part of the American musical scene, demand was steady for C. G. Conn instruments, which included bugles, French horns, and trombones.

With his factory producing a significant portion of all goods manufactured in Elkhart, Gerard quickly became a leader of the town's business community. In 1880, he became leader of the whole town when he was elected its mayor.

January 29, 1883, should have been a happy day for Gerard. It was his thirty-ninth birthday. Instead, it was marked by tragedy as the Conn factory caught fire. The city of Elkhart had no public water system at that time, so firefighters drilled through nearly two feet of ice on the Elkhart River to fetch water to put out the fire. But it was too late. The building was destroyed.

Gerard didn't give up. He set up shop temporarily in another building. Then he resigned as mayor so he could focus on building a larger factory where the old one once stood.

BARITONE

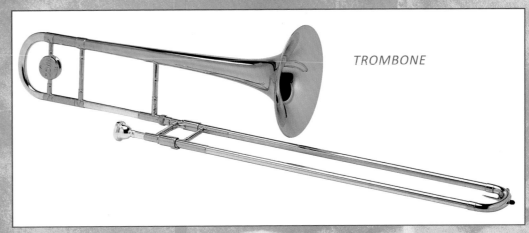

TROMBONE

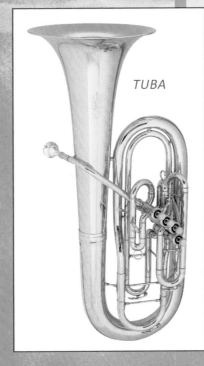

TUBA

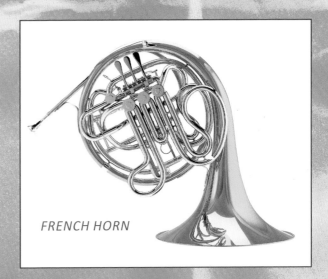

FRENCH HORN

CORNET

TYPES OF HORNS

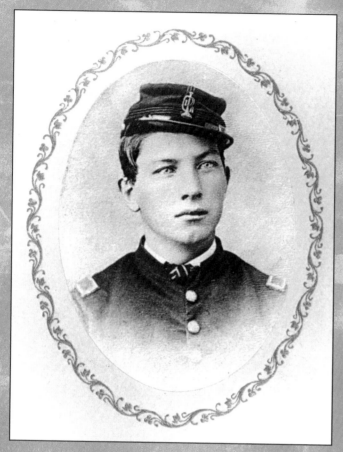

Civil War veteran Charles Gerard Conn

THE GOLDEN AGE OF AMERICA'S BRASS BAND

In the mid-nineteenth century, the all-brass band was a common fixture in American towns and cities. The brass band was a natural development of the woodwind band, a European tradition that wealthy colonists brought with them to America. The woodwind bands of the American Revolution were typically made up of instruments like the clarinet, oboe, and bassoon. These reed instruments could produce a variety of notes when musicians opened or closed holes along their length with small pads, called keypads. It wasn't until the early 1800s that brass instruments like bugles, trumpets, cornets, and trombones were given keypads and valves so that they might produce a wide range of sounds as well.

In the 1840s, a Belgian instrument maker named Adolphe Sax created an entire family of valved brass instruments, called saxhorns. Sax would later invent the saxophone, a popular woodwind instrument. Because of the brass saxhorns' versatility and full sound, they were quickly adopted by orchestras and military bands. And because saxhorns were easy to play, amateur musicians liked them, too.

Soon brass bands were springing up in small towns across America. Performing in concert halls or on outdoor bandstands, they provided musical entertainment in an era without radio, television, or record players. When the Civil War broke out in 1861, brass bands were attached to regiments of soldiers to "incite the men to heroic deeds," as one music journalist reported. Civil War bandsmen like Gerard Conn—also a Union sharpshooter who rose to the rank of officer—played in camp between battles to lift soldiers' spirits. They were also put to work in the heat of battle caring for the wounded.

After the war, bands began to mix both brass and reed instruments, along with percussion. These groups, called symphonic or concert bands, became enormously popular between 1880 and 1925. Thousands of people attended their performances, which were often outdoors or at special events. Great bandmasters like Patrick Gilmore and John Philip Sousa, as well as the musicians who played in their bands, were the celebrities of the day. Many of them played and endorsed C. G. Conn instruments.

Today, concert bands can be found at schools, universities, and as a part of the military. These groups perform a variety of music, including marches, popular songs, and adaptations of classical works first written for orchestras.

Popular musicians of the day endorsed Conn instruments.

Charles Gerard Conn's ties to the military were strong, even after his formal military service ended. In 1884, he organized the 1st Regiment of Artillery in the Indiana Legion. The Indiana Legion was an early version of the Indiana National Guard, the state's volunteer militia. Gerard became the regiment's first colonel, a title that would stay with him the rest of his life.

Colonel Conn

With his new facility up and running, Gerard—now known as "Colonel Conn"— decided to expand C. G. Conn. In 1886, he purchased an instrument factory in Worcester, Massachusetts. Now C. G. Conn had a presence on the East Coast, and two factories able to produce his instruments.

In 1892, the first American-made saxophone was built by the C. G. Conn company. It was created with the input of famed saxophone virtuoso E. A. Lefebre. Lefebre had met the saxophone's inventor, Adolphe Sax, and had previously used instruments supplied by Sax himself. With Lefebre's help, the C. G. Conn saxophone was constructed by factory foreman Ferdinand August "Gus" Buescher. It was a close copy of the Sax original. Buescher worked for Conn from 1876 to 1893, then started his own instrument manufacturing company in Elkhart. Eventually, more than fifty businesses would manufacture musical instruments in Elkhart, which became known as "the band instrument capital of the world."

Lefebre was one of many important nineteenth-century musicians and bandleaders who played or endorsed C. G. Conn products, called the Wonder line of band instruments. Between 1889 and 1892, Conn added his own clarinets, flutes, and piccolos to the Wonder mix.

SOUSA AND THE SOUSAPHONE

John Philip Sousa was born in 1854 in Washington, D.C. He grew up around military music, as his father played trombone in the U.S. Marine Band. When he was thirteen, John Philip tried to run away to join a circus band. His father enlisted him in the Marines instead. After his discharge from the Marines, he became leader of the U.S. Marine Band, then formed his own civilian band in 1892. The Sousa Band became enormously popular, performing all over the world. Sousa became known as "The March King" because of the many lively and patriotic marches he composed.

In 1893, Sousa and Philadelphia instrument maker J. W. Pepper collaborated to create a new instrument. Sousa wanted a brass horn with a low, mellow sound for his concerts. Pepper designed an instrument that was worn over the shoulder and whose bell pointed up for a warm, muted sound during concerts. The sousaphone's sound was similar to the tuba, but the tuba was not worn over the shoulder. Pepper named the instrument the sousaphone in Sousa's honor.

Other musical instrument makers introduced their versions of the sousaphone. Conn's 1898 sousaphone was called a raincatcher because its bell pointed up to the sky. Later, the bells of Conn sousaphones would point forward, making them louder and suitable for marching.

John Philip Sousa

Raincatcher

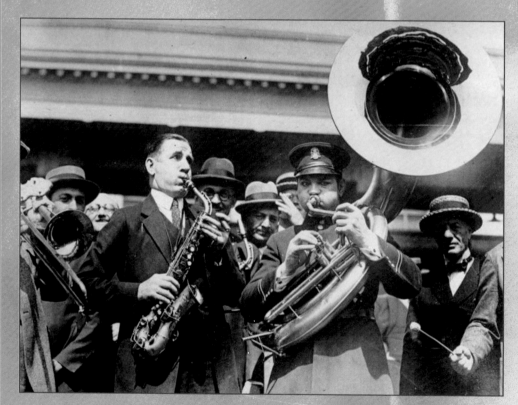

Former heavyweight champion Jack Dempsey takes a crack at the sousaphone, 1930.

Colonel Conn and his employees were always experimenting with new instrument designs. In 1898, the Conn company developed its "raincatcher" version of the sousaphone, a special type of tuba named for bandleader and composer John Philip Sousa. Sousa preferred Conn's version of the sousaphone for his bands.

In 1900, Conn introduced the Wonder portable reed organ, a small organ that folded into a convenient carrying case. The colonel also produced some highly unusual instruments. His megaphone-like Immensaphone of 1907 was the largest horn in the world, measuring twelve feet in diameter and thirty-five feet long. Conn's pocket cornet was so tiny it could slip into a pocket.

On May 22, 1910, while Colonel Conn was on a fishing trip in California, fire again destroyed the Conn factory in Elkhart. Upon Conn's return four days later, the community showed its support by decorating storefronts with flags and banners and hosting a parade in his honor. Once again, the colonel vowed to rebuild in Elkhart. By 1911, the new Conn factory was up and running. Just three years later, two hundred and fifty men and fifty-three women were producing more than eight hundred instruments a month in the new facility.

Colonel Conn turned seventy-one in 1915. In just over forty years, he had transformed C. G. Conn from a firm that crafted only cornets to a company known worldwide for the quality of its instruments, from brass to woodwinds, strings to percussion. It was quite an accomplishment—and Colonel Conn decided it was time to retire.

THE POCKET CORNET, THE SMALLEST EVER MADE!

Also called a miniature, parlor model, or tourist model, the pocket cornet was a horn with its metal tubing wrapped very tightly. This made the instrument much smaller than a regular cornet. A pocket cornet was only seven or eight inches long, yet it played in the same key and with as wide a range of notes as a full-sized cornet. C. G. Conn first advertised its "parlor cornet" in the late 1880s. They were included in Conn sales materials until the early 1920s. Other instrument manufacturers made pocket cornets at the end of the nineteenth century as well.

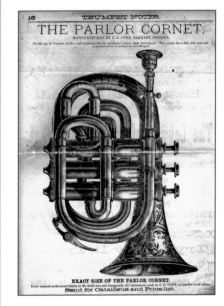

An advertisement for The Parlor Cornet, late 1880s

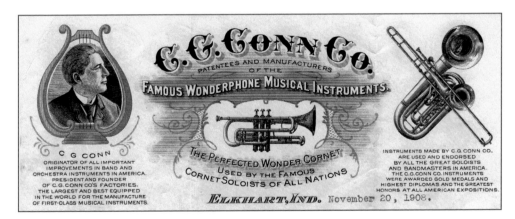

Conn company letterhead, 1908

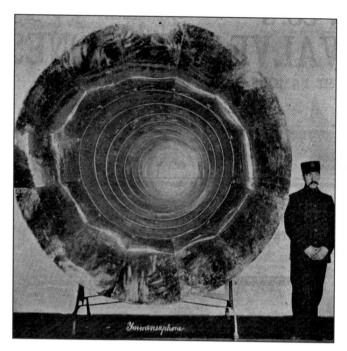

Colonel Conn was fascinated by unusual instruments. In 1907, he made the Immensaphone, the largest horn in the world.

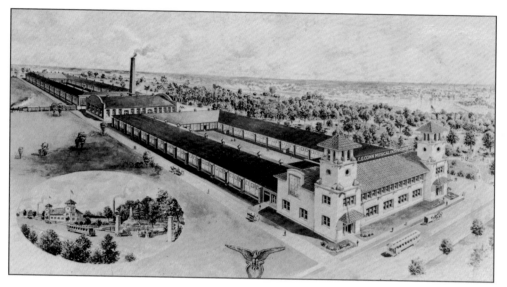

The third Conn factory, built in 1911

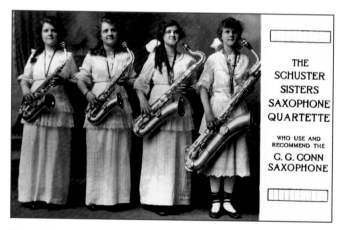

THE SCHUSTER SISTERS SAXOPHONE QUARTETTE

WHO USE AND RECOMMEND THE C. G. CONN SAXOPHONE

The Schuster Sisters Saxophone Quartette. The Schuster sisters were popular entertainers who appeared at leading hotels throughout the United States. Here they are endorsing Conn saxophones, ca. 1915.

That August, the colonel sold the company bearing his name—along with all his other Elkhart assets, including the *Daily Truth* newspaper—to a corporation headed by Carl Dimond Greenleaf. Greenleaf was a flour miller from Ohio, a respected businessman whose only musical experience was the bit of self-taught horn he played in his free time. Keeping the name now so familiar in the band instrument industry, Greenleaf's group rechristened the colonel's company C. G. Conn, Ltd.

By the early 1920s, a saxophone craze had swept across America, thanks to the popular new music called jazz. The saxophone's tone, somewhere between the mellow clarinet and the bolder-sounding brass instruments, was well-suited to this energetic new musical form. Responding to demand, Conn developed a full range of saxophones, from the small, high-pitched soprano sax to the large, low-pitched bass, plus the sarrusophone and Conn-O-Sax. For a few years in the 1920s, Conn saxophones even came in a variety of colors, including purple, green, rose, and blue.

Saxophones soon made up a great part of C. G. Conn, Ltd's output. But Carl Greenleaf had his doubts about the sax fad. He wanted to open up new markets for other Conn instruments. For this, he looked to schools.

Music education had first been introduced in public schools in 1838.

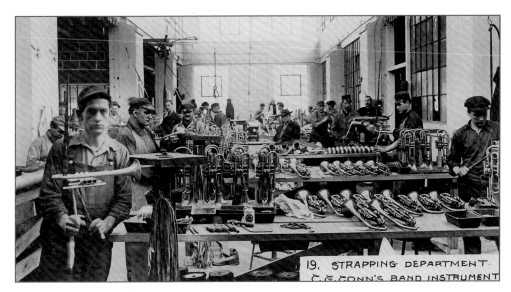

Conn's strapping department, where the brass horns were polished

THE SCIENCE OF MUSIC

STROBOCONN AND STROBOTUNER—*The Stroboconn, developed in 1936, and its smaller, simpler cousin the Strobotuner, introduced in 1954, were devices for the visual measurement of sound. By measuring musical pitch, the Stroboconn and Strobotuner could tell if an instrument was in tune. The Stroboconn was often used by school bands between World War II and the 1960s.*

CONNSONATA ORGAN—*In 1946, Conn introduced the first all-electronic organ, the Connsonata. Conn would eventually produce organs of every size, from small spinets for home use to larger models suitable for churches and theaters.*

ELECTRONIC CLINICIAN AND DYNALEVEL—*The Electronic Clinician, developed in 1957, was a large, complex device that gave a visual indication about the quality of musical tones. A similar product, the Dynalevel, which measures a sound's volume, was introduced in the 1960s.*

Since then, a few excellent high school bands had emerged, but most schools offered only piano, voice, or violin lessons. Greenleaf thought that students, schools, and communities—as well as his business—would benefit if more students played music together, as a "team." He wanted to see more school bands in America.

But who would teach students to play the wide range of instruments in a band? Schools would need qualified band instructors. So Greenleaf founded the Conn National School of Music in Chicago. It was the first "band teacher" school of its kind and trained hundreds of the country's first school band directors.

To help promote and encourage school bands, Greenleaf assisted in organizing a series of National High School Band Contests. The first annual competition, held in Chicago in 1923, drew seventeen bands. The Joliet, Illinois, high school band took first place. By 1933, seventy-four bands involving more than 5,000 students competed.

Carl Greenleaf was also committed to innovation. From 1928 to 1969, C. G. Conn, Ltd.'s Experimental Laboratory and Division of Research, Development and Design produced a variety of technologically advanced instruments and devices. At that time, it was not common for a musical instrument company to run its own research laboratory.

Young musicians measuring pitch with a Stroboconn

LOWELL MASON BRINGS MUSIC TO SCHOOL

In 1833, church music director and composer Lowell Mason cofounded the Boston Academy of Music. He believed strongly in the value of music education for children, having taught children's music classes since 1829 at a Boston church. In 1834, Mason published his Manual of the Boston Academy of Music, *an important book that explained his principles and methods of vocal training for children. Many people became interested in the idea of bringing music education into Boston's public school system. The school board was skeptical, however.*

In 1837, Mason agreed to teach music for a year, without salary, in one of the city's public schools. His music classes at that school were so successful that in 1838 Mason was put in charge of music education for all of Boston's public schools. Soon, public school systems across the country adopted music education for their students.

Lowell Mason

The stock market crash of 1929 hurt many musical instrument makers. C. G. Conn, Ltd., however, had enough cash reserves to buy up several of its rivals.

World War II brought big changes for the company. At the federal government's request, the Elkhart factory manufactured items for the military, such as compasses, altimeters, and gyro-horizon indicators. Between 1942 and 1946, Conn produced virtually no musical instruments for sale to the public. Customers turned instead to smaller instrument companies. Nearly a decade later, during the Korean War, C. G. Conn, Ltd. was tapped again to produce specialized equipment for the military.

In 2002, after a series of transactions, Conn was combined with its fellow band instrument manufacturer Selmer by Steinway Musical Instruments, Inc., to form Conn-Selmer.

The firm's educational wing, the Conn-Selmer Institute, trains school band directors and offers music education assistance to school systems, students, and parents.

By providing quality instruments and educational support for every kind and level of musician, Conn-Selmer continues to work toward its mission of every man, woman, and child participating in instrumental music.

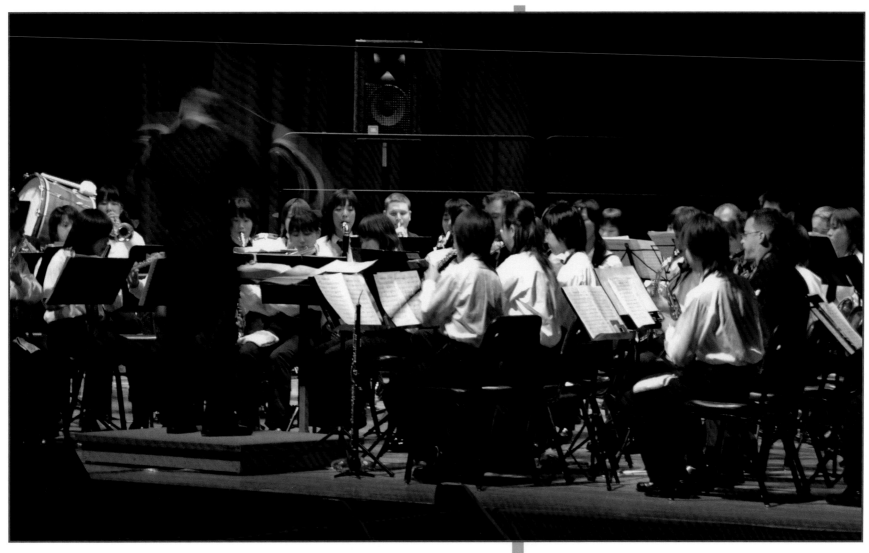

The Conn-Selmer Institute provides support for music educators and students.

Early Martin pape...

All of this s...
He wanted to be...
new baby daugl...
system of his h...
for the United S...

The Marti...
They landed a...
Markneukirche...
the end of 183...
"Frederick"—a...
Though he sol...
week—he also...
music and violi...
and sold instru...

C.F. kept ca...
his daily transa...
paying for then...
merchandise f...
children. And...
their handwriti...

Among th...
screws." These...
used them on t...
all of the tunin...

4

Martin
Guitar Artistry

Fᴵꜰᴛᴇᴇɴ-ʏᴇᴀʀ ᴏʟᴅ Cʜʀɪꜱᴛɪᴀɴ Fʀɪᴇᴅʀɪᴄʜ Mᴀʀᴛɪɴ loved to build guitars.

His father, Johann Georg Martin, was an accomplished woodworker, known throughout the Saxony region of Germany for his fine furniture and handcrafted guitars. C.F. learned all that he could from his father. But he wanted to know more.

So in 1811, C.F. left his family's home in Markneukirchen, Saxony, for the bustling city of Vienna, Austria. There he landed an apprenticeship with Johann Stauffer, one of Europe's most famous makers of guitars, violins, and cellos.

Young C.F. did very well at the Stauffer workshop. He quickly rose to the position of foreman, learning not only how to make guitars, but also how to run the business. After fourteen years with Stauffer, Christian went to work for a harp builder, Karl Kuhle, also of Vienna. Kuhle's musical daughter—harpist and singer Ottilie Lucia—caught Christian's eye, and the two were married in 1825.

PARTS OF THE GUITAR

HEAD—The head, or headstock, is the uppermost part of the guitar. It holds the tuning pegs.

TUNING PEGS—One end of the guitar's strings is attached to the tuning pegs. As a peg is twisted, the string is loosened or tightened. The tighter the string, the higher its pitch.

STRINGS—The typical guitar has six strings, which are plucked or strummed to create sound.

NECK—The neck is the long part of the guitar over which the strings pass.

FRET—A fret is a strip of material that is positioned across the neck of a stringed instrument. When a musician pushes a string down onto a fret, the string sounds at a certain pitch. Frets are usually made of metal, ivory, or wood, and are laid into a groove cut into the instrument's neck.

BODY—The body is the hollow part of the guitar. It acts as a sound box, capturing the strings' vibrations and amplifying them, or making them louder. The body's shape makes the guitar easier to hold and can also change its sound.

SOUND HOLE—The sound hole helps a guitar project its sound.

BRIDGE—The bridge anchors one end of the strings, while the tuning pegs hold the other end.

GUITAR

The guitar is a
that produces sou
typically hollow,
sides that curve i

The modern gu
Babylonian and E
one of its closest
the thirteenth ce

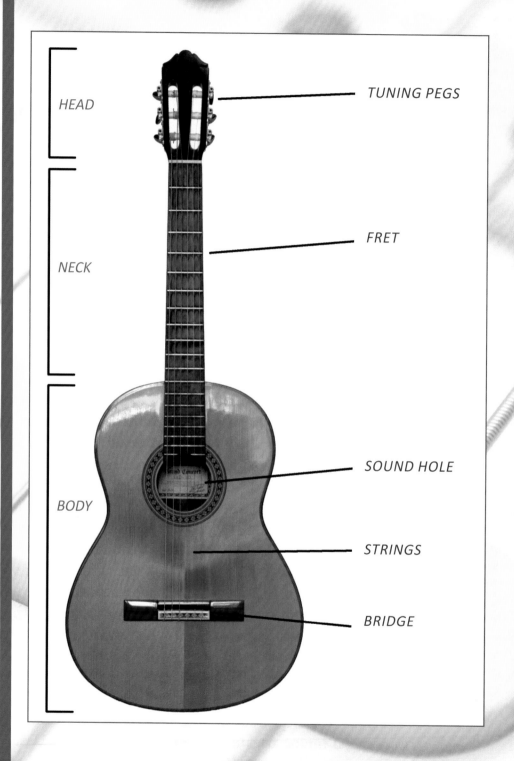

HEAD

NECK

BODY

TUNING PEGS

FRET

SOUND HOLE

STRINGS

BRIDGE

from his teacher in Vienna, Johann Stauffer. The "Stauffer head" was one of the things that made C. F. Martin guitars unique.

C.F. also incorporated Stauffer's design for an adjustable neck. Using a long screw that extended from the back of the neck into the body of the guitar, the neck could be moved closer to or farther away from the strings. In this way, the guitar could be adjusted to suit the musician's playing style.

C.F. built all kinds of guitars for all sorts of people. Some of his instruments were fancy, decorated with pearl and ivory. Others were very plain, with simple wooden pegs and no decoration. C.F. built each guitar by hand. His more elaborate instruments sold for as much as $80, equivalent to more than $2,000 today. Simpler models sold for less than $20, or less than $500 in today's money.

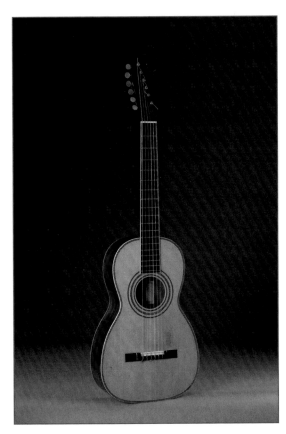

Martin guitar, with Stauffer head, ca. 1835

Though C.F. seemed to be prospering in America, New York City was nothing like his beloved Germany. It was crowded and dirty. C.F. missed the peaceful Saxony countryside. He and Ottilie wrote letters to their friends in Germany, telling them that they were thinking of returning home. And they kept in touch with German friends who'd also come to America, like Heinrich (now "Henry") Schatz.

Schatz had moved away from New York City in 1835, purchasing land in the rolling hills of eastern Pennsylvania, near the town of Nazareth. When Ottilie visited Schatz and his wife at their new home, she was immediately

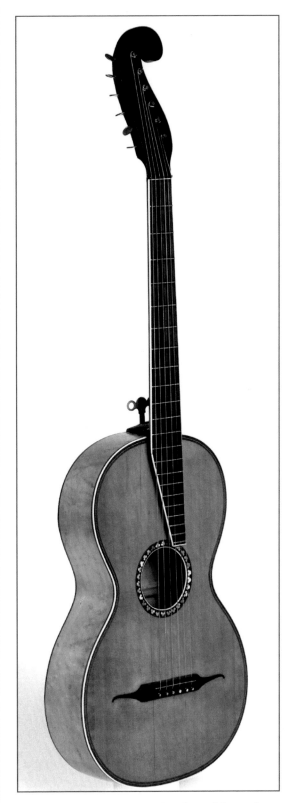

Martin Stauffer head, with adjustable neck, ca. 1838

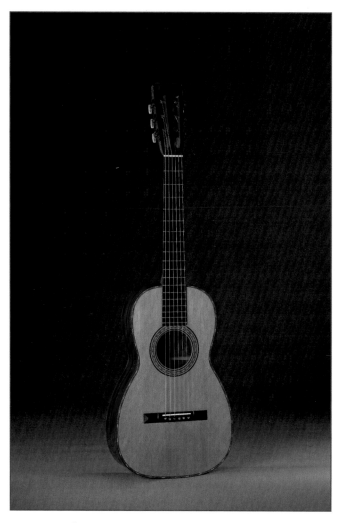

Martin parlor guitar, ca. 1860

reminded of Saxony. After careful consideration, the Martins decided to join their friends in Pennsylvania. C.F. sold his store, and in 1839 the Martin family moved to Cherry Hill, just outside of Nazareth.

The Martins built a two-story house on eight peaceful acres. The home included a ground-floor workshop where C.F. produced his guitars. To sell his instruments, C.F. worked with partners in New York City.

By the early 1850s, C.F. was shipping more than twenty handcrafted guitars a month from Cherry Hill. To assist him, he hired a half-dozen craftsmen. They used a steam-powered saw to cut guitar parts from rosewood, ebony, and mahogany. They carved decorative inlays from abalone seashells or the ivory of imported elephant tusks.

At Cherry Hill, C.F.'s guitar designs began to change as demand grew for plainer, more rugged instruments. Banjos were more popular than guitars in America at the time. So C.F. did away with fancy European styling, like the curved headstock and metal Vienna screws. His guitars became simpler and sleeker. These instruments were the first to look like the acoustic, or non-electrified, guitars that we know today.

C.F. also came up with an important structural design that would make his guitars truly unique. Inside, he mounted strips of wood in the shape of

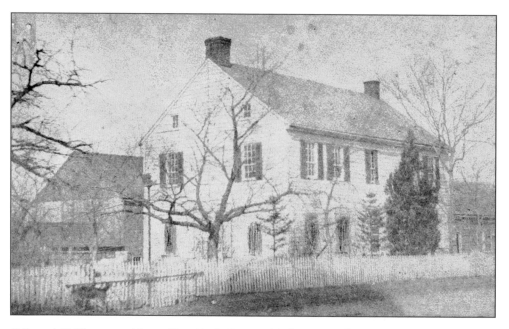

C.F. and Ottilie moved from New York City to this home in Cherry Hill, Pennsylvania, in 1838.

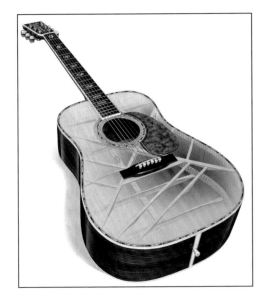

The X-pattern bracing inside a Martin guitar

an X under the soundboard, or the top of the guitar. Though other guitar makers also braced their instruments with strips of wood, theirs simply ran across the width of the body. By bracing his guitars diagonally with an X-pattern, C.F. was able to make Martin instruments sound much better and last much longer.

By the 1850s, C.F. and his team at Cherry Hill were building two hundred to three hundred guitars a year. To make sales and production easier, C.F. created standard sizes for his guitars. Famous musicians played and promoted Martin instruments. Music dealers in big cities as far away as Nashville, New Orleans, and St. Louis now wanted to sell Martin guitars in their stores. C.F. decided it was time to move once more, but the Martins didn't move far.

When the family had first relocated to Pennsylvania, all of the land in Nazareth was owned by the Moravian Church. Only church members were allowed to live there. By the late 1850s, the church began selling property in Nazareth and allowing nonmembers to live there. In 1857, the Martins, who had joined the Moravian Church, purchased an entire block on North Main Street in Nazareth.

By 1859, the family had built a large house and workshop, followed by construction of a full-fledged factory next door. It is said that guitars were assembled in the family's kitchen for a short time while the factory was being completed.

BANJO ON MY KNEE

Like the guitar, the banjo is a fretted instrument with a long neck. Its body is flat and circular, similar to a shallow drum.

African slaves who'd been transported to the American south created the earliest banjos from gourds, which resembled instruments they knew from their homeland. White people learned to play the instrument, then modified it into the round, flat shape.

The banjo became an important component of American minstrelsy. The minstrel show was a form of entertainment that began in the 1830s and included skits, dancing, and music performed by white people in blackface. Using burnt cork, and later greasepaint or shoe polish, the performers would blacken their faces. They would sing, dance, or act in ways that borrowed from or made fun of the culture of slaves and other people of African descent.

By the 1900s, minstrelsy was in decline due to changing attitudes about race and the rise of vaudeville entertainment.

Martin tenor banjo

C. F. Martin Jr.

Frank Henry Martin, son of C. F. Jr.

Life was good for the Martin family in Nazareth. C.F. Sr. adored his children, grandchildren, and his big Newfoundland dog. C.F.'s cousin from Markneukirchen, Christian Frederick Hartmann, moved in next door, and other German immigrants with connections to the Martin family lived nearby. Often, the Martins would host concerts in their home by well-known guitarists who were traveling through Pennsylvania. While C.F. did not play guitar, Ottilie did. So did one of their daughters, Emilie Clara. C.F. made special instruments for them both.

C.F. Sr. had suffered a stroke in the mid-1850s. He relied more and more on others to keep the family business running smoothly, especially C.F. Jr. and C. F. Hartmann, his cousin from Markneukirchen. So, in 1867 he made it official. He formed a co-partnership with his son and cousin and changed the name of his company from C. F. Martin to C. F. Martin & Co. C.F. Sr. died six years later, apparently of complications from a second stroke. He was seventy-seven. C. F. Martin Jr. took charge of the family business.

Despite the death of the company's founder, demand for Martin guitars remained strong. The company's New York City distributor sold more than 250 instruments a year in the mid-1880s. To keep up with demand, C.F. Jr. expanded the Martin factory in 1887 and installed modern steam-driven woodworking machinery. Unfortunately, he died the next year after a brief illness at the age of sixty-three.

It now fell to C.F. Jr.'s son, Frank Henry Martin, to assume leadership of the company. Frank Henry Martin, age twenty-two, was the first American-born son to head C. F. Martin & Co.

By that time, Martin was the oldest guitar company in the country, and certainly one of the most respected. But it seemed stuck in old-fashioned ways. All of its craftsmen had been born and raised in Germany and were steeped in centuries-old woodworking traditions. There'd been no real changes to the Martin guitar line in nearly three decades.

By the 1890s, guitars by any maker seemed hopelessly out of style. The mandolin was the latest craze. And Frank Henry wanted to cash in. So he created a line of mandolins and in 1896 issued Martin's first catalog, which featured not a single guitar.

Martin still produced guitars, too. But it slashed its prices to compete with larger guitar factories that offered cheaper instruments. It also cut

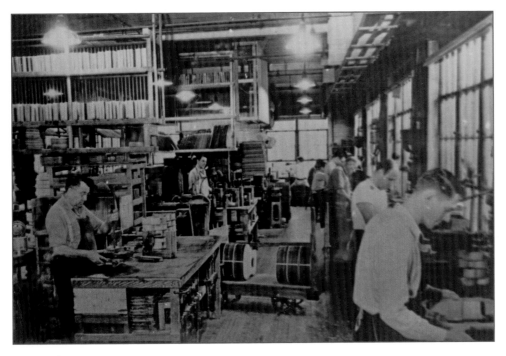

Martin factory, 1912

The mandolin is a descendant of another chordophone, the lute. A lute is a plucked-string instrument with a rounded body and short neck that was popular in southern Europe during the Renaissance. Mandolins look similar to lutes but are generally smaller.

European immigrants brought their mandolins with them to the United States, where they became very popular in the late 1800s. Many of the European mandolins, especially those from Italy, featured a bowl-shaped back. Because they resembled a potato beetle, these instruments were nicknamed taterbugs.

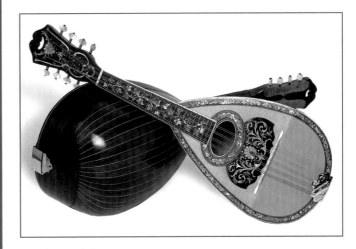

Bowl mandolins

out its New York City distributor, selling directly to music stores and instructors across the country. And for the first time since the company's launch in 1833, the stamp on every instrument read C. F. Martin & Co., Nazareth, PA, instead of C. F. Martin & Co., New York.

The growing market in the West, where jobs in mining and agriculture put money into people's pockets, accounted for half of the company's entire revenue in the late 1800s. To familiarize folks with its products in far-off cities like San Francisco, California, and Spokane, Washington, Martin introduced its first full-line catalog in 1898.

Still, mandolins became the C. F. Martin & Co. mainstay. Between 1906 and 1909, the company that had been founded on guitars built more mandolins than guitars. Mandolin bands, both professional and amateur, were everywhere.

But something was brewing in the Pacific that would change the American musical landscape once again. In the 1870s, Portuguese immigrants arriving in Hawaii to work the sugarcane fields had brought with them a small, guitarlike instrument called the *branguinha*. Hawaiians

In the early twentieth century, ukuleles became all the rage.

Frank Henry Martin's sons, Frederick and Herbert

liked the instrument's sound when the player's fingers skittered across the strings. The Hawaiians renamed it *ukulele*, which means jumping flea, and it quickly became one of the most popular instruments on the islands.

In 1915, Hawaii—a U.S. territory, but not yet a state—hosted a pavilion at the Panama-Pacific International Exposition in San Francisco. The months-long event was a world's fair to celebrate the completion of the Panama Canal. Hawaii wanted to show off its people, land, and products to promote tourism and business. One of the most popular exhibits at the Hawaiian pavilion was a show featuring ukuleles and hula dancing. Interest in Hawaiian music soon swept the country.

As he had done with the mandolin, Frank Henry seized the sales opportunity. Martin introduced its first ukuleles in January 1916.

Along with the ukulele, another hallmark of Hawaiian music was the Hawaiian-style guitar. A Hawaiian guitar is played with the instrument flat on the musician's lap. Instead of using his fingers to push down the strings on the guitar's neck, the Hawaiian guitar player uses a steel bar. This gives the Hawaiian guitar, also known as the steel guitar, its distinctive "gliding" sound.

Martin began producing guitars especially for Hawaiian-style playing. Most were made of koa wood, a tree native to Hawaii. Koa gave these guitars a unique look and sound. Strings made of steel, instead of the typical gut, or animal fiber, gave the guitars extra volume. Like Martin's ukuleles, its Hawaiian guitars were a huge hit.

Soon players of standard guitar, especially those who played in groups with other instruments, wanted the louder steel strings for their instruments. One of those musicians was Jimmie Rodgers, who would come to be known as the "Father of Country Music." By the end of the 1920s, all Martin guitars came with steel strings.

Frank Henry's sons joined their father in the family business after they graduated from Princeton University. Frederick was given responsibility for manufacturing in 1916. Herbert took over sales duties in 1919, traveling the country to call on music stores and distributors.

Thanks largely to the Hawaiian music boom, sales of C. F. Martin instruments increased every year during the 1920s. By the mid-twenties, the company was selling more than ten thousand ukuleles a year. Before 1915, fewer than a dozen workers could easily fill the orders. By 1929,

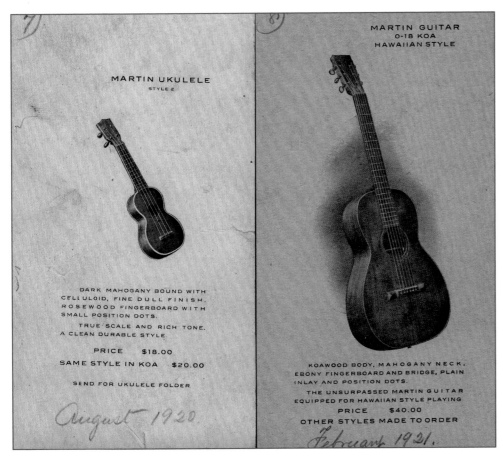

Martin followed the early-twentieth-century interest in Hawaiian music by producing ukuleles and guitars mostly made with wood from Hawaiian koa trees.

JIMMIE RODGERS AND THE BIRTH OF COUNTRY MUSIC

Country music originated in the southern United States, particularly in the Appalachian Mountain regions. Immigrants who settled there brought their own musical traditions and instruments with them—the Irish fiddle, the Italian mandolin, the Spanish guitar, the African banjo. Musicians mixed and blended their styles, creating a unique sound. In the 1920s, the newly launched radio industry helped spread the distinctive sound, dubbed hillbilly, of artists like Jimmie Rodgers and the Carter Family.

Jimmie Rodgers was born in Mississippi in 1897. Working as a brakeman on the railroad, he picked up bits of songs and guitar techniques from fellow workers and hobos. He alternated between railroad jobs and his first love, music, singing and strumming his way throughout the South. He wound up in the mountains of North Carolina, performing weekly for a radio station there.

Jimmie made several records for the Victor Talking Machine Company. One, called "Blue Yodel (T for Texas)," showcased his distinctive yodeling vocals and sold millions of copies.

In the 1930s, mandolinist Bill Monroe of Kentucky and his guitarist brother Charlie played hillbilly, or country music, as the Monroe Brothers. But while other hillbilly mandolinists played sweetly in the background, Bill Monroe played fast, fiery notes that put his instrument in the spotlight.

The Monroe Brothers split up in 1939. In 1945, Bill formed a band with banjo picker Earl Scruggs, guitarist Lester Flatt, and fiddler Chubby Wise. They called themselves the Blue Grass Boys, and the popular, kicked-up hillbilly sound they created—with Monroe's mandolin center-stage—came to be known as bluegrass.

Monroe's music influenced many artists, including rock-and-roll pioneer Elvis Presley, who had a hit with his rendition of Monroe's tune "Blue Moon of Kentucky." Bill Monroe was inducted into the Country Music Hall of Fame in 1970.

Martin guitar factory, 1912

Bill Monroe

the Martin factory had more than doubled in size and more than seventy employees churned out Martin guitars, mandolins, and ukes.

While the 1920s were among C. F. Martin & Co.'s best years, they were marked by tragedy, as well. In 1927, Herbert Martin died suddenly after a brief illness. And the 1929 stock market crash launched the Great Depression, an era of tremendous economic hardship for the entire country. With millions of people out of work, selling guitars became extremely difficult.

Frank Henry and Frederick went into survival mode. They began an active product-development campaign, adding new instrument models and changing existing ones in hopes of sparking sales.

One of those changes to an existing product was the introduction of a fourteen-fret neck. Before 1929, guitars typically had twelve frets. Called the Orchestral, the longer-necked guitar was a huge success, especially with guitar players in cowboy bands, the latest musical trend. The fourteen-fret neck proved so popular that it became the standard design not only for all Martin guitars, but ultimately for the entire American guitar industry.

Another Martin innovation was born, or reborn, during the Depression

years. Back in 1916, Martin had teamed with the Chas. H. Ditson Co., a large music retailer on the East Coast, to produce an unusual guitar. It was an oversized instrument called the Dreadnought, sold only at Ditson stores. Named after a World War I battleship, the Dreadnought's extra-wide, extra-deep body gave it a loud, low sound. Though it did not sell very well when it was first introduced, Martin reintroduced it in 1931 after Ditson went out of business.

Soon country artists and singing cowboys like Gene Autry were playing their own Dreadnoughts, often with custom details. Autry's most famous Dreadnought featured his name inlaid in pearl script on the guitar's neck.

Gene Autry

The Martins weren't the only ones experimenting with guitars during the Depression years. In 1932, a little-known Los Angeles company called Ro-Pat-In started selling what looked like a strange frying pan. It was actually the first modern electric guitar.

It was a small-bodied, long-necked instrument made of aluminum that was played in the lap while seated, like the Hawaiian guitar. It used an "electric pickup" to create an electrical signal from the vibration of the instrument's strings. The signal was then amplified.

The concept of the electric pickup was not new. Since the late 1800s, there had been attempts at electrifying stringed instruments. But those experiments did not have the same results as the "frying pan." The sound of the Ro-Pat-In guitar wasn't simply louder. It was a singing, soaring tone all its own that could cut through any band's horn section or any audience's chatter.

The Ro-Pat-In instrument sent many other guitar companies scrambling to introduce their own versions of an electric guitar. Not the Martins. They focused on what they knew best: building the high-quality

George Breed

THE ELECTRIC PICKUP

An electric pickup is made from a magnet wrapped with a coil of wire. When the magnetic field around the magnet is disturbed, the motion creates an electric current in the wire.

The first guitar using an electric pickup for amplification was introduced in 1928 by Chicago's Stromberg-Voisinet company. On this instrument, the pickup's magnet was attached to the top, or soundboard, of the guitar. When the strings made the guitar's soundboard vibrate, the magnet moved. The electrical current created by this design was weak, so the sound it created, even when amplified, was quiet. Not many people were interested in a quiet guitar, so the Stromberg-Voisinet instrument was pulled from production.

Even before the Stromberg-Voisinet guitar, others had experimented with electricity and fretted instruments. In 1890, U.S. Navy officer George Breed was granted a patent for the electrification of a guitar. In Breed's design, the guitar's metal strings were made to vibrate by sending a pulsating electric current through them. The electrified strings then passed through a magnet. The result was not a louder guitar, like the electric guitar we think of today. Rather, Breed invented a guitar whose notes could sustain—or sound—forever, or as long as the string stayed electrified.

THE WEAVERS AND THE FOLK MUSIC REVIVAL

The group the Weavers was formed by Pete Seeger. Folk music is traditional music, songs of a region or community that are typically passed from generation to generation orally, not by recordings or writing. Often, the lyrics, or words, of folk songs are about important issues, such as not being treated fairly.

In 1950, the Weavers had a string of hits that included "On Top of Old Smokey," a version of African American folk singer Lead Belly's "Goodnight, Irene," the South African Zulu song "Wimoweh" (later known as "The Lion Sleeps Tonight"), and the campfire favorite "Kumbayah," believed to have come from slave heritage.

Groups like the Weavers, the Kingston Trio, and Peter, Paul and Mary brought new audiences to folk music with their fresh versions of "old-fashioned" songs.

The Weavers

acoustic—meaning non-electric—instruments the company had been crafting for a century.

Frank Henry and Frederick's survival tactics worked. While many other musical instrument companies were sold or collapsed during the Depression, C. F. Martin & Co. remained in business. But it faced a new set of challenges as the United States entered World War II after the bombing of Pearl Harbor on December 7, 1941. The government severely restricted the use of metal and other materials, so instruments were stripped of fancy ornamentation or dropped from production completely.

But the company's biggest loss of the 1940s was its leader. Frank Henry Martin died in 1948 at the age of eighty-one. He had seen the family business successfully through the first half of the twentieth century. Now it was Frederick's turn as president of C. F. Martin & Co. In his fifties, a husband, a father, and a veteran of the Depression, Fred was a careful, frugal businessman. He saw no need to bring back the fancier instruments the company had dropped during World War II.

In fact, the Martin Dreadnoughts had become the standard for the emerging musical genres of bluegrass and folk. High-profile musicians like Lester Flatt, Jimmy Martin, and Mac Wiseman of the popular group the Blue Grass Boys all played Martin Dreadnoughts. And Martin was the instrument of choice for Fred Hellerman, guitarist for the Weavers, a pioneering act of the folk music movement.

By the late 1950s, it was clear that the electric guitar was here to stay. It was key to the new rock-and-roll sound. So Fred, now joined by his son Frank Herbert Martin, decided to add an electric guitar to the Martin product line. Instead of designing a totally new guitar around the electric technology, as most other electric guitar makers did, the Martins simply added an electric pickup to a few of their existing acoustic models in 1959. They did not sell very well.

Martin was known for its beloved acoustic guitars. And it was those guitars that sold the best for the company, especially with the folk music explosion. Demand for Martin's acoustic guitars had grown so much that by the early 1960s there was no way to fill orders and to keep customers happy. So Fred and Frank decided to build a bigger factory. Finally, Martin production could keep pace with sales.

By the dawn of the 1970s, the company was making over 22,000

guitars a year. But the company faced competition from Japanese guitar makers who offered similar-looking guitars at a cheaper price. Also, new electronic instruments like synthesizers ate away at the market for guitars and other more traditional instruments. By 1982, the company was barely selling 3,000 guitars a year.

In 1992, however, when famous rock guitarist Eric Clapton appeared on *MTV Unplugged* playing a pair of old Martin guitars, the company was swamped with requests for those same instruments. The company asked Clapton if he would lend his name to a new special edition guitar, with part of the sales going to charity. Clapton agreed. He has since inspired more Martin Signature Editions guitars than any other performer.

In 2004, the Martin company celebrated an historic milestone—its 1,000,000th guitar. Today, over 175 years after its founding, the Martin Guitar Company continues to thrive. Martin fans from near and far flock to Nazareth, Pennsylvania, watching in amazement as dedicated craftspeople build some of the finest guitars in the world—just as Christian Frederick Martin did back in 1833.

On March 4, 1994, astronaut Pierre Thuot carried a Martin Backpacker Guitar on a thirteen-day mission aboard the Columbia *space shuttle, making it the first guitar in outer space.*

Eric Clapton triggered a renewed interest in traditional Martin guitars.

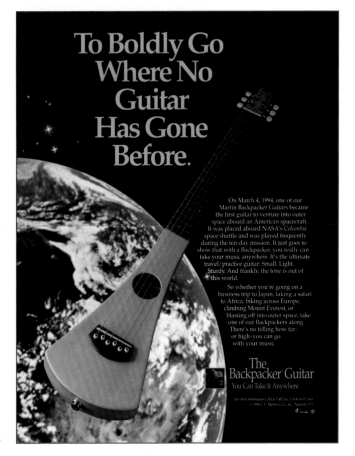

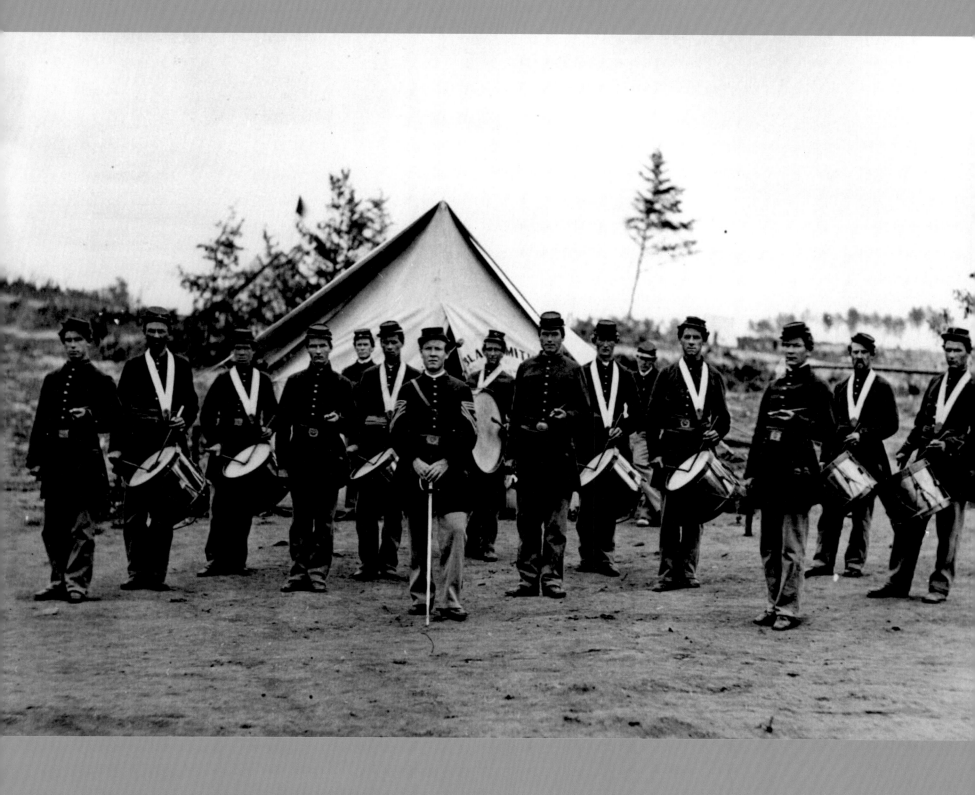

5

Ludwig
The Most Famous Name on Drums

It was a warm summer night in 1887. Eight-year-old William F. Ludwig, whose family had emigrated that year from Germany to Chicago's west side, craned his neck for a better view. Great crowds filled the tent that had been erected in William's neighborhood for the evening's political rally. And the most wonderful noise William had ever heard filled the sticky air, echoing off the buildings like thunder. Drums!

A parade was rounding the corner, headed by a drum corps of the First Regiment Illinois National Guard. A drum major wearing a tall, plumed hat led thirteen drumming soldiers. William liked the marchers' fancy uniforms. He marveled as the soldiers pounded out precise rhythms on their shiny drums. He was fascinated by the rhythmic patterns that made him want to march. Then and there, William decided that he would become a drummer, too.

When William told his father that he wanted to play drums, his father was not happy. William's dad was a professional trombone player. He didn't think drumming required serious musical skills. He wanted William to take up a "real" instrument, like the violin,

DRUM

An instrument with skin or plastic stretched over a frame that is struck, usually with the hand or a drumstick, to produce a sound. Most drums play rhythm, or the beat of a piece of music.

Drums have existed for thousands of years in almost every part of the world. In addition to music making, drums have been used for religious ceremonies, storytelling, and even to send messages.

U.S. Marine Corps drummer

which William's grandfather played. But William didn't want to learn violin. He loved the drums. Finally, William and his father compromised. He could play drums if he also studied violin. So William began studying with his grandfather, and that fall he started lessons with one of Chicago's best drummers, John Catlin.

William was eager for his first session with Catlin, who also drummed with the Illinois National Guard. But William's excitement quickly turned to disappointment when he found he wouldn't be learning to drum on a fancy instrument like the soldiers had. In fact, he wouldn't be learning to drum on any drum at all. Instead, Catlin prescribed for William a heavy practice pad—a flat wooden disc that doesn't make a drum's loud sound; a pair of thick, black drumsticks; and Bruce and Emmet's *Drummers' and Fifers' Guide*, a Civil War–era instruction book full of rudiments. Rudiments are the basic rhythmic patterns every drummer needs to know. Drummers string rudiments together to create or accompany music.

Week after week, William lugged his pad, sticks, and book the two and a half miles to Catlin's house for his lessons. Catlin insisted that William learn the rudiments on the practice pad before he would allow William to play on a drum.

Three years went by, during which William also learned to play violin, first from his grandfather, and then from a professional teacher. Soon he was assigned a violin solo at a student concert. His teacher insisted that the battered, miniature violin William had been playing was inappropriate for the show. Instead, he recommended a new violin, which the Ludwig family could not afford. Ashamed of his inferior instrument, William refused to practice violin at all. He devoted all of his spare time instead to his drum rudiments.

William's father was not pleased. He threatened to stop William's drum lessons unless his son took up another instrument. Again, William and his father compromised. William agreed to lessons on a second-hand piano his father bought for him; the drum instruction continued.

Finally, the moment William had been waiting for arrived. He was given his first drum. It was a snare drum with a brass shell, four inches deep and fourteen inches in diameter. It was an old instrument but in good condition, purchased by William's father for three dollars from a drummer at a local theater. Now William really was a drummer!

William was thrilled with his drum. He paraded throughout the neighborhood, tapping out his rudiments for all to hear. Soon, a neighbor campaigning for city council hired William to become his official one-man drum corps. William made his first money as a musician—fifty cents a parade—as he marched through the city streets on his neighbor's behalf. Before long, William was picking up more drumming jobs, filling in at amateur band rehearsals, local picnics, and winter dances.

At that time, most work for drummers involved two musicians. One played the bass drum, the other the snare. Some theater drummers played "double drums," an arrangement where the snare was placed in front of the drummer, and the bass drum with a cymbal on top was placed to the right. The drummer would strike the bass drum and cymbal, then quickly move to the snare. Theater drummers accompanied dramatic and vaudeville performances.

In 1893, the World's Fair came to Chicago. William's father landed a job playing trombone with a twelve-piece orchestra at one of the fair's attractions. The group was auditioning for a drummer; William's dad suggested he try out. When William arrived at his audition with his trusty brass snare, he was surprised to find a double drum setup. William had never played double drums before. Suddenly, he felt nervous and scared.

William muddled through the audition march the best that he could. He knew he wasn't playing the music correctly. When he was done, William was hardly surprised that the conductor told him to pack up and go home for more practice. He was disappointed in himself and embarrassed that he'd failed in front of professional musicians. But he didn't give up. He vowed to practice harder than ever. William convinced his father that drums were most important to him; his father allowed him to quit piano to focus on his beloved drumming.

That winter, fourteen-year-old William made the acquaintance of a theater double drummer who'd started using a foot pedal to play the bass drum. Using a pedal freed up the drummer's hands to do more on the snare. William was intrigued and decided he wanted a pedal for himself. He bought one of the homemade devices for two dollars from a local woodworker. The pedal, operated by the drummer's heel, was made entirely of wood, including the knob that struck the drum. William also purchased a bass drum and a wooden snare-drum stand, assembling a basic drum kit,

This Civil War–era instruction book contained many rudiments.

SNARE

BASS

TOM-TOMS

TYPES OF DRUMS

Drums can be "pitched," or tuned, to play a certain note, or "nonpitched." A drum's pitch can be changed by adjusting the tension on the drum's head. The tighter the head, the higher the pitch. A drum's size and shape can affect its pitch, too. Generally, the larger the drum, the lower its pitch. Several different-sized drums in a set, chosen to harmonize with each other, like bongos, can also be considered pitched drums.

SNARE—A shallow, nonpitched drum that makes a distinctive cracking noise. The sound comes from snares—wires or cords—along the drum's underside. The snares vibrate against the drum as it is struck.

BASS—A large pitched or nonpitched drum that produces a low, booming noise. It can be mounted on a stand, as in an orchestra, or carried, as in a marching band. It can be played with a hand-held mallet or with a foot pedal, as with a drum set's "kick" drum.

TOM-TOM—A pitched drum with no snare. In African and Native American cultures, the tom-tom is played with the hands. The tom-tom was added to the standard drum kit in the early twentieth century.

also known as a drum set or trap set. Playing at outdoor ice-skating rinks, he quickly learned how to use the foot pedal. William liked using the pedal. Older drummers were leery of the "bloomin' contraption."

William picked up odd drumming jobs around Chicago until the spring of 1895 when he and his father joined the Wood Brothers Circus. It was a traveling show that played throughout Chicago in spring and summer, then moved by horse-drawn wagon to the southern states in the winter. William was dazzled by the performers' colorful costumes and the bright-red circus wagons. He couldn't wait to see the world! The schedule was tough: a pair of sixteen-act shows, a parade, and an after-circus concert almost every day. But William liked the lively pace and fun carnival atmosphere. Many nights, he would lead the wagon train, fast asleep on a pony with a lantern strapped to his back.

One rainy morning in December 1895, the circus wagons were loaded onto a riverboat in Arkansas, headed for New Orleans, Louisiana. Curious to see how the boat's churning paddle wheels worked, William leaned over the railing. Suddenly, he lost his balance and fell into the murky river! He tried to swim to the boat, but it was moving too fast. He tried not to panic as he watched the boat disappear.

William swam to shore, climbed out, and started running. He eventually reached a town, where a storekeeper gave him food and water and pointed him in the direction of the riverboat's next stop. William caught up with the show that afternoon. He expected his father to be angry; instead, his father was glad to see him. But William's father decided that the circus business wasn't for the Ludwigs. The two returned home.

Back in Chicago, William dedicated himself to professional drumming. He played all sorts of jobs—dances, circuses, vaudeville shows. Aiming to make himself a more versatile performer, he bought a set of bells and a three-octave xylophone, on which he could play a few polka numbers. William landed more jobs, including one at a concert hall at the 1898 Trans-Mississippi and International Exposition held in Omaha, Nebraska. Many great bands of the day played at the exposition, which was similar to a state fair.

It was at the exposition that William first heard the U.S. Marine Band led by John Philip Sousa. Sousa's percussionists were considered among the finest in the country.

The New York Times *reported that the 1898 Trans-Mississippi and International Exposition in Omaha, Nebraska, opened with the cheers of 100,000 people and the music of one hundred bands.*

also known as a drum set or trap set. Playing at outdoor ice-skating rinks, he quickly learned how to use the foot pedal. William liked using the pedal. Older drummers were leery of the "bloomin' contraption."

William picked up odd drumming jobs around Chicago until the spring of 1895 when he and his father joined the Wood Brothers Circus. It was a traveling show that played throughout Chicago in spring and summer, then moved by horse-drawn wagon to the southern states in the winter. William was dazzled by the performers' colorful costumes and the bright-red circus wagons. He couldn't wait to see the world! The schedule was tough: a pair of sixteen-act shows, a parade, and an after-circus concert almost every day. But William liked the lively pace and fun carnival atmosphere. Many nights, he would lead the wagon train, fast asleep on a pony with a lantern strapped to his back.

One rainy morning in December 1895, the circus wagons were loaded onto a riverboat in Arkansas, headed for New Orleans, Louisiana. Curious to see how the boat's churning paddle wheels worked, William leaned over the railing. Suddenly, he lost his balance and fell into the murky river! He tried to swim to the boat, but it was moving too fast. He tried not to panic as he watched the boat disappear.

William swam to shore, climbed out, and started running. He eventually reached a town, where a storekeeper gave him food and water and pointed him in the direction of the riverboat's next stop. William caught up with the show that afternoon. He expected his father to be angry; instead, his father was glad to see him. But William's father decided that the circus business wasn't for the Ludwigs. The two returned home.

Back in Chicago, William dedicated himself to professional drumming. He played all sorts of jobs—dances, circuses, vaudeville shows. Aiming to make himself a more versatile performer, he bought a set of bells and a three-octave xylophone, on which he could play a few polka numbers. William landed more jobs, including one at a concert hall at the 1898 Trans-Mississippi and International Exposition held in Omaha, Nebraska. Many great bands of the day played at the exposition, which was similar to a state fair.

It was at the exposition that William first heard the U.S. Marine Band led by John Philip Sousa. Sousa's percussionists were considered among the finest in the country.

The New York Times *reported that the 1898 Trans-Mississippi and International Exposition in Omaha, Nebraska, opened with the cheers of 100,000 people and the music of one hundred bands.*

Program for a United States Marine Band concert, under the direction of John Philip Sousa, 1892

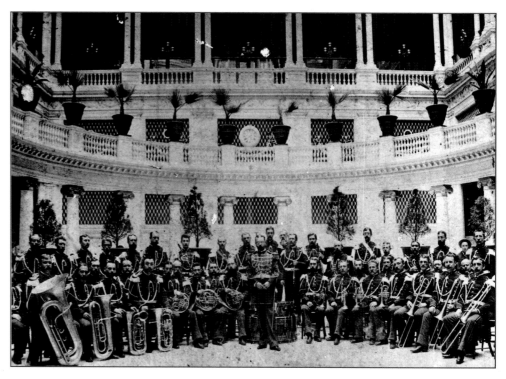

John Philip Sousa and the United States Marine Band, Palace Hotel, San Francisco, 1892

Inspired by the Sousa drummers, William decided he wanted to play in a fine concert band like Sousa's. He bought a set of tympani drums, also known as kettledrums, and started lessons with Joseph Zettleman, a renowned tympanist with the Theodore Thomas Symphony Orchestra, which would later become the Chicago Symphony Orchestra.

Zettleman's coaching helped William land a position with the Chicago Marine Band, a top-notch concert band that toured all over the United States. For an engagement at the Buffalo Exposition in New York, the Marine Band added some members of the Sousa Band, including drummer Tom Mills. Mills played an unusual drum that caught William's eye. It was all metal, and the tension on its two heads could be adjusted independently. William had never seen such a thing. He was intrigued by the drum's tone and power. For the next year, he pestered Mills to sell it to him. Mills finally did.

After four years with the Chicago Marine Band, William accepted a job as tympanist with the Henry W. Savage English Grand Opera

Company. William played in every state in the Union with the Savage group from 1904 to 1909, when the company disbanded. He switched from the tympanis of opera to ragtime's double drums when he joined the *Ziegfeld Follies* orchestra in Chicago. For this job, William used a "swing" pedal, in which a leather strap connected a foot pedal to a beater rod that swung from the top of the bass drum.

William, who was familiar with foot pedals from his earlier days on his trap set, found that the swing pedal was not powerful or nimble enough for ragtime's swift tempos and strong accents. The beater arm was simply too long, the beater too far from the drum head, to keep pace.

William had an idea. Why not shorten the beater rod? And why not connect it closer to its beating spot? Secretly, he built a few rough models. One day, he brought one of his wooden prototypes to a rehearsal. It worked! With his new pedal, he was able to keep perfect time.

Word soon spread among Chicago's drummers that William F. Ludwig had invented an innovative new pedal. William was swamped with requests to make the pedal for other musicians. He couldn't turn them down.

For help, he turned to his younger brother Theobald, also a professional drummer. Together, the two opened a small drum shop, which they called Ludwig & Ludwig. Between drumming jobs, the brothers assembled William's pedals. As fast as they could make them, drummers purchased them. In 1909, William applied for and was granted a patent for his "drum and cymbal playing apparatus."

Still a drummer at heart, William accepted a position as tympanist with the Pittsburgh Symphony Orchestra, while Theo stayed in Chicago to make the Ludwig pedals. The Ludwigs' sister, Elizabeth, joined the business to take care of the financial records. On the road with the Pittsburgh Symphony, William acted as salesman, showing off his product wherever he went. Who better to sell a drum accessory than a drummer? Sales of the Ludwig pedal took off.

Encouraged, William set to work on another idea he'd had in the back of his mind for years. He pulled out Tom Mills's old metal drum. Using it as a model, he and Theo devised their first all-metal, separate-tension snare drum. They added it to the Ludwig & Ludwig product line in 1911.

Elizabeth's husband, Robert C. Danly, was a tool designer for

TYMPANI

Also known as the timpani or kettledrum, the tympani is an enormous pitched drum that makes a loud or soft rumbling noise. The large bowl is commonly made of copper. The pitch of the tympani is changed by adjusting the tension of its drumhead, often by means of a pedal.

Tympani drums arrived in Western Europe with the Mongols, Ottoman Turks, and Muslims of the fifteenth century. Following Eastern custom, they were used in Europe as military instruments, played on horseback and paired with trumpets.

The first known orchestral score that included tympani drums was Jean-Baptiste Lully's 1675 opera Thesee. *Today, the tympani drums are the most important percussion instrument in the symphony orchestra.*

William Ludwig's children, Bettie and Bill Jr., around 1920, playing with—what else?—a drum

William Ludwig II, with his father's innovative foot pedal that changed the way drummers played the bass drum

International Harvester, makers of farm and construction machinery. Danly was skilled at designing and building mechanical items and had some thoughts about how William's pedal could be mass-produced. The brothers invited Robert to join the Ludwig & Ludwig team.

William rented a small barn in northwest Chicago, and he, Theo, and Robert went to work manufacturing Ludwig pedals and drums on a much larger scale. Robert immediately redesigned the foot pedal, making it from durable metal, and improved the all-metal drum. He also patented the first complete throw-off strainer for snare drums.

During his time with the Pittsburgh Symphony Orchestra, William had noticed a need for a less-expensive, higher-quality design for the tympani drum. Pedal-tuned tympani drums were much easier to play than tympani whose pitch had to be adjusted by hand. At that time, all pedal-tuned tympani came from Europe, thus they were very expensive. William told Robert of his idea; in 1913, Ludwig & Ludwig introduced the first pedal-tuned tympani drums made in America.

Even as Ludwig & Ludwig's sales soared, William continued to play drums professionally. By 1914, he was performing with the Chicago Grand Opera Company, where he met and fell in love with Elsa Gunkler, a young singer. The two were married in 1914. In 1916, he accepted the position of bass drummer in the Chicago Symphony Orchestra, working alongside his old tympani teacher, Joseph Zettleman. William and Elsa welcomed their first child, Bill Jr., that same year.

In October 1918, Theo died, a victim of a flu epidemic that swept the nation. William was heartbroken. Could Ludwig & Ludwig continue without his beloved brother? William decided it must, and he quit his symphony job to focus full-time on the business. Robert Danly did the same at International Harvester.

World War I brought restrictions on materials, particularly metal, but government orders for thousands of rope-tensioned, wooden field drums for the military kept Ludwig & Ludwig up and running.

After the war, the growing popularity of silent films—which were accompanied by often-grand orchestras—and radio programs that incorporated live music created new demand for Ludwig products. By 1923, Ludwig & Ludwig had added 10,000 square feet to its plant, employed 240 workers, and was the largest drum factory in the world.

Though William was no longer a professional drummer, he maintained personal relationships with many percussionists. He would take his family, including Bill Jr. and daughter, Bettie, to fancy Chicago theaters on Sunday afternoons, where they'd visit with drummers after the show. William invited drummers who were passing through town to the factory to watch Ludwig drums and pedals being made. He wanted Ludwig drums to be center-stage with the popular bands of the day so others could imagine themselves behind that same set of drums.

One of the most famous drummers of all time, Buddy Rich, began his long relationship with Ludwig when he was just a toddler. The son of performers, Buddy toured the vaudeville circuit in the early 1920s as "Traps," the Drum Wonder. As the curtain opened on his act, the tiny tot would be playing with all his might, but all the audience would see was a big Ludwig bass drum. Buddy would be standing behind it, pounding on a snare and the bass. Each year, as Buddy grew, his father would bring him to the Ludwig factory to be measured for a larger bass drum.

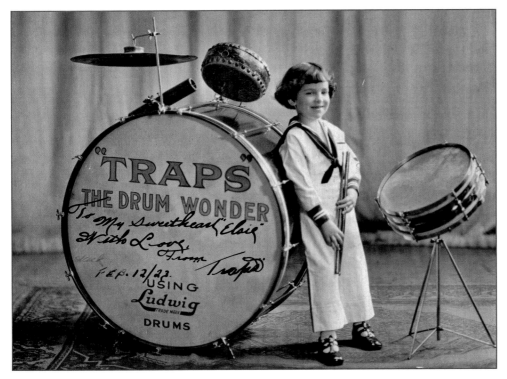

"Traps," The Drum Wonder: Buddy Rich as a child, on the vaudeville circuit, 1922

BUDDY RICH — CHILD STAR TO JAZZ GIANT

Bernard "Buddy" Rich started playing drums professionally as "Traps, the Drum Wonder" when he was just eighteen months old. By age four, he was performing on Broadway. He was completely self-taught.

While a teen, Buddy became interested in jazz drumming. In 1938, he joined big band leader Artie Shaw's orchestra, then moved to the Tommy Dorsey band the following year. With Rich's amazing speed, power, and precision on drums, as well as the song stylings of singer Frank Sinatra, the Dorsey orchestra became wildly popular.

From 1966 on, he led his own bands, which often featured young, fresh players. By performing mainly at colleges and universities, Buddy won over a new generation of fans.

Buddy Rich died in 1987. The Smithsonian Institution, a museum in Washington, D.C., acquired his drums. He is considered by many to be the greatest drummer of all time.

embrace the new technology. Older drummers, accustomed to calfskin, resisted the change. By the mid-1960s, though, almost all of Ludwig's drum orders included mylar heads. Calfskin was dropped completely by 1970.

In February 1964, a British rock and roll group called the Beatles appeared on the U.S. television program *The Ed Sullivan Show*. The Ludwigs happened to be watching that night. At first, they thought the band was a comedy act; the Beatles looked and sounded so different from popular American musical groups. Then the Ludwigs were stunned to see their name plainly visible—to millions of TV viewers across the nation—on the bass drumhead. They were puzzled; Ludwig bass drumheads didn't

William Ludwig II brought the original Ludwig company back to the family.

Ludwig is displayed on the bass drum in this re-creation of Ringo Starr's drum kit at the Cavern Club, Liverpool, England.

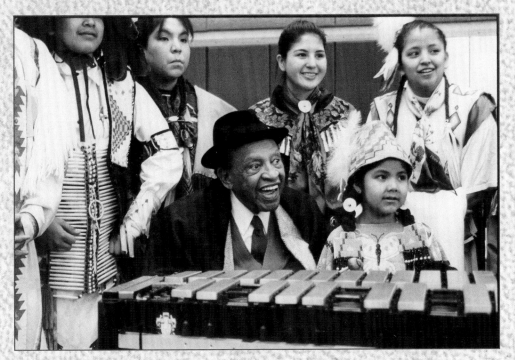

Lionel Hampton, one of the all-time great percussionists

In 2001, Ludwig introduced a special new vibraphone with gold bars as a tribute to Hampton.

GOOD VIBES — LIONEL HAMPTON

Lionel Hampton was an extraordinary percussionist who played several instruments, but he was best known for his innovative technique on the vibraphone.

Also called the vibraharp or, simply, the vibes, the vibraphone looks similar to a large xylophone, with aluminum instead of wooden bars. Like the xylophone, the vibraphone is played with mallets. Mallets are similar to drumsticks, tipped with heads of felt, cord, yarn, or rubber.

After graduating from high school, Lionel journeyed from Chicago to Los Angeles, where he landed a job drumming with the house band at the Cotton Club in Culver City.

In 1930, Lionel was asked to play on a recording with trumpeter Louis Armstrong. During a break, Lionel walked over to a vibraphone in the corner of the studio and started to play. He ended up playing vibes on Armstrong's tune "Memories of You." When the record became a hit, Lionel had introduced a new voice to jazz.

When clarinetist and big band leader Benny Goodman heard Lionel perform one night, he immediately invited Lionel to record with him, drummer Gene Krupa, and pianist Teddy Wilson. The Benny Goodman Quartet was the first group of jazz musicians to include both black and white players.

Playing with his own band or others, Lionel would become known for his unstoppable energy, dazzling showmanship, and remarkable musical skills on the vibraphone, drums, and piano. Lionel Hampton appeared on hundreds of recordings, many considered the best in jazz.

The "King of the Vibes" died on August 31, 2002. He was 94.

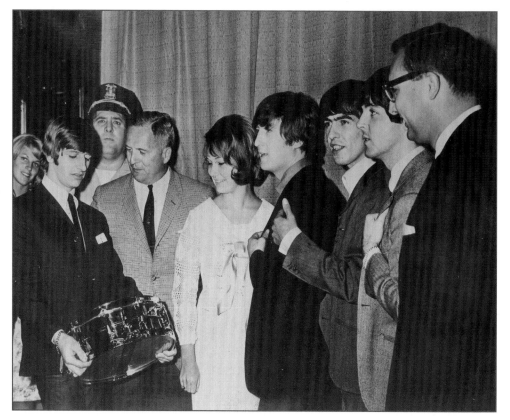

Ringo Starr, presented with a fourteen-karat gold-plated Ludwig snare drum

have the company logo on them. They would later learn that the Beatles' drummer, Ringo Starr, was so proud to own a Ludwig drum set that he insisted the logo be painted in large letters across his bass drumhead.

The next morning, orders for drum kits just like Starr's began pouring into the Ludwig offices. The company added a night shift to keep up, operating around the clock for the first time in its history. To express their appreciation to Starr, the Ludwigs presented him with a custom snare drum plated in fourteen-karat gold.

By the dawn of the 1970s, Ludwig was the largest percussion manufacturer in the world. Bill Jr. had been appointed company president in 1970, replacing William, who was now in his nineties.

The year 1973 was a landmark for Ludwig. Expanding on plastics technology, it launched a new line of drums called Vistalites, made of transparent acrylic. The unusual see-through drums came in clear plastic

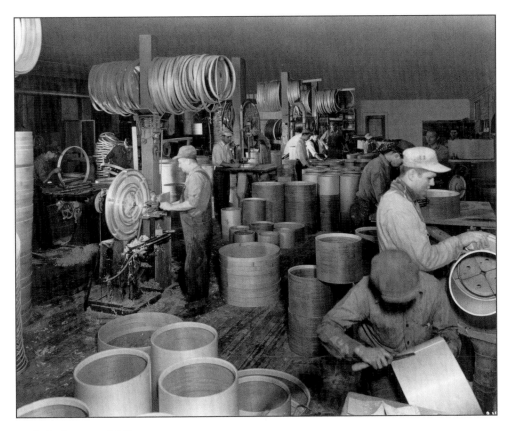

Ludwig factory, 1940

Ludwig celebrated its one-hundredth anniversary in 2009.

or five different tints— red, blue, amber, green, and yellow. "It's here … but where?" asked an early Vistalites ad, which continued, "So crystal-clear is Vistalite you can see the stars perform behind and beyond these gem-like outfits … even the drum heads are transparent. See them at your local Ludwig dealer. But, remember. Look closely."

The distinctive Vistalites were used by many high-profile drummers. John Bonham of the heavy-metal rock band Led Zeppelin was well-known for his amber-colored Vistalite set. His son, Jason Bonham, also a professional drummer, uses Vistalites, too.

But 1973 was a sad year for Ludwig, as well. On July 8, William F. Ludwig, the company founder, died. He was ninety-three. It was left to Bill Jr. and his son Bill III to run the family business.

Today, Ludwig is part of Conn-Selmer, a subsidiary of Steinway Musical Instruments. It continues to create quality percussion products.

Tivoli Vistalite drums, created by Ludwig in 1978, featured small light bulbs built into the drum shells.

From beginners buying their first snare and sticks to national recording artists heading out on concert tours, Ludwig serves all drummers' needs.

"We are a company of drummers ... thinking, creating, living, and dreaming drums every day," a recent Ludwig sales catalog states. And, as a company of drummers, Ludwig remains the most famous name on drums.

Jason Bonham, son of original Led Zeppelin drummer John Bonham, with his transparent Vistalite drums

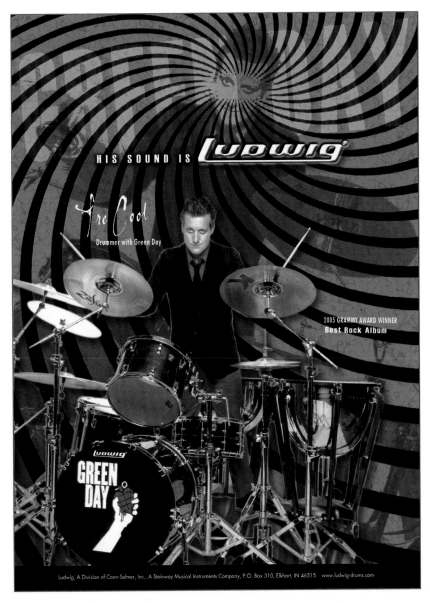

Tré Cool, drummer for Green Day, endorsing Ludwig drums

Three generations of Ludwigs: From left to right, William Frederick Ludwig, William F. Ludwig II, and William F. Ludwig III

6

Hammond
Electricity into Sound

IT WAS 1907, AND TWELVE-YEAR-OLD LARRY HAMMOND stood in the Paris offices of the Panhard company. The French firm of Panhard et Levassor had been making automobiles for nearly a decade, among the first to do so.

Larry's mother had told him to come, and when Idea Hammond told you to do something, you did it. Finally, Panhard's chief engineer agreed to see him.

Young Larry showed the man his design. Larry had worked out a method to shift automobile gears automatically. His mother had even taken him to a lawyer to file a patent for it.

The engineer couldn't believe it. The design was absolutely correct, if not practical for the time. "Little boy," the engineer said, "who really invented this?"

Larry assured the man that he'd thought up the device himself. It took some time to convince the engineer, but eventually the man felt certain that this child had dreamed up the complex device.

*Larry Hammond,
ca. 1901*

Twelve-year old Larry Hammond designed a method to shift automobile gears automatically. (Automobile pictured: 1905 Panhard et Levassor)

Panhard couldn't use Larry's idea, the engineer told him, but he hoped that when Larry grew up he would come to work for the company.

Little did the man at Panhard know that Larry would go on to invent a myriad of products, from a weather gadget and tickless clock to 3-D glasses and a musical instrument for which he's best known: the Hammond Organ.

Laurens "Larry" Hammond was born on January 11, 1895, in Evanston, Illinois. His mother, Idea Hammond, had studied at the prestigious Art Institute of Chicago before marrying Larry's father, William Hammond, a successful banker.

When Larry was just two years old, his father died. Larry's mother decided to take Larry and his three sisters to Europe. She thought they could live more cheaply there, the children could get a better education, and she could resume her art studies.

It was on a beach at Brighton, England, that Larry rode in his first horseless carriage, or automobile. For sixpence you could ride down the beach and back in the strange-looking carriage with the noisy motor. Little Larry was intrigued.

Idea and her children traveled across Europe, spending time in

Carbide bike lamp

Larry Hammond, with his mother, Idea, ca. 1910

Switzerland and Germany before settling in Paris. There, Larry went to a fine school. His mother enrolled him in dancing lessons and bought him a bicycle with a carbide lamp. When the calcium carbide in the lamp was mixed with water, it created a flame. Carbide lamps were used in lighthouses and automobile headlights, and by miners in caves.

Larry was fascinated by the chemical reaction of calcium carbide and water. Sometimes he would drop carbide into a gutter full of water, astonishing passersby with flames alongside the curb. One day he dropped carbide into the huge inkwell on his teacher's desk; the inkwell erupted like a volcano, spouting geysers of black ink around the classroom.

Larry was always curious about how things worked and why. Another day at school, he and a classmate decided to see what would happen if they hooked the water and gas lines together. Natural gas was used for indoor lighting at that time, as well as for cooking. Larry and his friend ran a rubber hose from the bathroom spigot to the end of a light's gas pipe, then turned on both the light and the faucet. Before long, screams came from the kitchen. Because the water pressure was stronger than the gas pressure, water was spouting up from the stove's burners like fountains!

Larry was not the best student. He hated Latin, French history, and especially geography. He wasn't very good at math. On the other hand, "if the subject had anything to do with mechanics," he once told a friend, "you could kind of reason from one thing to another, and you could understand how a steam engine works. You could construct it in your mind."

Like his mother, Larry adored art. He enjoyed literature but was not fond of poetry, which he felt wasn't straightforward enough. One of Larry's sisters taught him how to play chess; soon he was beating seasoned players.

The 1912 patent for a barometer that Hammond invented when he was sixteen

His heroes were microbiologist Louis Pasteur—best known for inventing pasteurization, in which liquids are heated to reduce harmful bacteria and other microorganisms—and aviator Alberto Santos-Dumont, who designed, built, and flew the first dirigible, or steerable, balloon. Santos-Dumont balloons could often be seen flying just above the streets of Paris.

Larry's favorite thing to do was tinker. He liked to take things apart, see how they worked, like the Edison cylinder and gramaphone—an early "record" and record-playing device—he bought for himself.

When Larry was fourteen, his mother moved the family back to Evanston. Larry was enrolled in Evanston High School. With his French clothes and his knowledge of French, not American, history, Larry didn't fit in at first. He wasn't a good athlete, and was made fun of often. He confided in his mother that he felt like an outsider.

Idea suggested that he audition for the school play. He did, and found he was very good at acting. His classmates so respected his acting and speaking abilities, in fact, that they elected him president of the senior class.

Success on the stage didn't lessen Larry's zeal for mechanical things, however. One winter, he designed a mechanism that would shut the furnace damper at the Hammond house using a series of alarm clocks, strings, and weights. Larry also created a device that would wake him up a half-hour early if he needed to shovel snow from the sidewalk before school. He balanced a crate outside in such a way that if a half-inch of snow fell, the crate would tip over and close an electrical circuit attached to an alarm clock that ran a half-hour fast.

When Larry was sixteen, he created a special kind of barometer, an instrument for measuring air pressure, useful in predicting the weather. Larry's barometer was super-sensitive, which made it a good educational tool for high school science teachers. Larry patented his invention and sold it, earning about three hundred dollars—which wasn't bad for a teenager in 1911. Perhaps, Larry thought, he could make a career of inventing things.

After graduating from Evanston High School, Larry set out for Ithaca, New York, and the College of Engineering at Cornell University. Though he was studying mechanical engineering, he mistakenly took an advanced electrical engineering test one day. To the professor's surprise, Larry passed the test! Because of that, he was graduated from the school.

Larry's friends at Cornell asked him what he was going to do next. "I'm going to be an independent inventor," he told them. There was no such thing, his friends replied. An inventor goes to work for somebody else's company, they told him. An inventor researches and invents things for a corporation. Larry disagreed. "The fact that you don't know any independent inventor," he said to his friends, "doesn't mean that there couldn't be one."

But before he could become an inventor, Larry needed to support himself. He took a job with the McCord Manufacturing Company, which made car radiators in Detroit, Michigan. He started out as a radiator inspector. But Larry soon had an idea that would make McCord radiators more effective. He shared his idea with the chief engineer at McCord. The engineer was impressed. Larry was not an inspector anymore.

Then came World War I. Larry volunteered and was sent to France with an engineering regiment, constructing railroads and bridges for the military. A few years after he returned from the war, he rented space in a nearby machine shop and went to work for himself.

Larry had some ideas about clocks that he wanted to explore. He'd always found the loud ticking of spring-driven clocks annoying. So in 1920, Larry invented a "tickless" clock, in which the motor was encased in a soundproof box. But what if a clock could be powered by electricity instead of a spring? Such a clock would never need to be wound to make it run, Larry thought. And it could probably be constructed to keep very accurate time.

Larry soon came up with a synchronous motor, or a motor that revolved in phase with the alternating current electricity that was then becoming standard in homes across the United States.

Though Larry had invented his synchronous motor with its use for a clock in mind, it first became an important component in the field of moviemaking. Larry found that he could use his new motor to create three-dimensional motion pictures. First, he would film scenes through a pair of cameras placed at the distance separating human eyes. Then he would project images from both cameras so they overlapped onto a screen. When viewed through a device with a revolving shutter that exposed the scene to one eye and then the other, the image appeared three-dimensional. Larry's synchronous motor powered the revolving shutter.

Louis Pasteur, one of Larry Hammond's early heroes

Hammond's patent for his stereoscopic picture viewer, 1928. His revised design led to his creation of 3-D glasses.

A theater in New York City purchased Larry's movie system. They installed the viewing devices on every seat. When the production—which they had named Teleview—opened, it was an instant sensation. People flocked to the theater to see what seemed like trains barreling past them, children swimming toward them, and Native Americans dancing around them. But interest in Teleview quickly fizzled, thanks to the clumsy viewing devices, and the show closed within a month.

Not one to give up, Larry redesigned his invention. Simple cardboard spectacles, with one lens of red plastic and the other green, replaced the complex Teleview devices. Larry showed his streamlined system to Florenz Ziegfeld, creator of the *Ziegfeld Follies*, an elaborate stage show in which dozens of pretty young women in lavish costumes sang and danced alongside famous entertainers of the day.

Ziegfeld was impressed with Larry's spectacular 3-D effects and incorporated them into his 1922 production. Audiences were impressed too; Larry earned $75,000 from the Ziegfeld shows.

With his earnings, Larry was able to take his new bride, Mildred Anton-Smith, on an extended tour of Europe. Larry had known Mildred when they were children in Paris. Mildred's family had since moved to New York City, where she and Larry became reacquainted, fell in love, and married.

The Hammonds lived on Larry's 3-D money for a few years, but with a baby on the way in 1925, Larry went back to his laboratory. Soon he got a call from his cousin in Illinois. The cousin had invested money in a new business, the Andrews Radio Company, which was nearly bankrupt before it had even produced a single radio. Larry and E. F. Andrews, chief inventor at the radio firm, joined forces, founding the Andrews-Hammond Laboratory to replace the Andrews Radio Company.

The pair's first project was a device called the A-Box. Radios at that time were powered by batteries, which used direct current electricity. But batteries eventually wore out and had to be replaced. Perhaps radios could be operated using household alternating current, the inventors thought. Their solution was the A-Box, which changed alternating current from a household electrical outlet into the direct current radios required. The A-Box was soon put into production in the pair's tiny lab over a grocery store in Larry's hometown of Evanston.

Larry Hammond

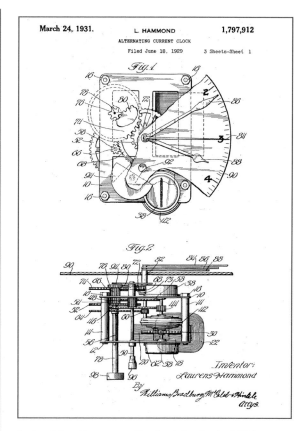

Patent for Hammond's electric clock, 1931

In time, the company built profits of $175,000, an impressive sum in those days. But soon the inevitable happened: radio manufacturers brought out units that could be plugged into wall outlets.

Larry and Andrews turned their attention to other inventions. Using his synchronous motor and his ideas for the tickless clock, Larry finally perfected his electric clock. These he sold through his newly formed Hammond Clock Company.

Hammond clocks were highly accurate and sales were brisk. To keep up with demand, the factory was moved from Evanston to a larger

"Tickless" clock

Bridge was a popular card game in the United States. In the depths of the Great Depression, Hammond invented an electric card-dealing bridge table. When a deck of cards was enclosed in a drawer, the contraption whirled around and dealt out four hands of bridge.

building in Chicago. But by 1930 and the dawn of the Great Depression, sales of clocks came to a virtual standstill. Clock companies were going out of business wherever you looked.

Hammond Clock Company was saved from bankruptcy by two key business deals. Wrigley Chewing Gum purchased half a million eighty-nine-cent plastic Hammond clocks to give away as premiums. And the Postal Telegraph Company placed a $75,000 order for large clocks for their offices nationwide.

Nearly seven hundred people worked at the Hammond Clock Company. Even in the difficult economic climate, Larry felt responsible for keeping them employed. He knew that clocks alone would not keep his company alive. Again, Larry looked in new directions to keep his employees working.

What he came up with was an odd device: an electric card-dealing bridge table. It was a table with a contraption at its center that used a rubber thumb to deal four hands for the popular card game known as bridge. Though at $25 it was priced high by Depression-era standards, fourteen thousand of the unusual tables were sold by Christmas of 1932. But the Hammond company stopped production as the Depression's grip tightened.

Larry needed a truly monumental invention, something exciting, something revolutionary. So he consulted his list. "I used to make up lists of things that were basic ideas that I might develop," he explained many years later. "The smart thing for an inventor to do is to put together the old tricks you have done before, and one of the things I listed was something that could use a tremendous lot of these little motors we used in clocks."

Larry thought and thought about his synchronous motor, which was used in the Hammond electric clocks. He remembered something that he'd learned: anything that can be an electric motor can also be an electric generator. He had an idea. If he reconfigured his motor so it generated electricity, then the electric current could be used to produce sound. But what could be the use of producing sound? Music.

Larry thought back to his boyhood days attending church with his mother. He loved the music that came from the big, beautiful pipe organ. *What if my little motors could be tone generators for a musical instrument*, he wondered, *maybe an organ that could be used in churches?*

HISTORY OF THE ORGAN

An organ is a wind instrument consisting of metal or wood pipes that are controlled by one or more keyboards.

Since primitive times, there have been instruments that use several pipes blown by a single player, such as panpipes or the pan flute. Typically, shorter, slimmer pipes produce higher tones, and longer, wider pipes produce lower tones. The panpipes are named for the Greek god Pan. According to myth, Pan loved a nymph who had been turned into a reed by her sisters. Pan made a pipe from that reed so he could sing of his love forever.

The first known organ was invented by the Greek Ketsibios of Alexandria around 200 BC. His instrument, known as a hydraulus, or water organ, was made of a set of pipes of different lengths that produced various sounds when air was forced through them. The air came from a bell immersed in water, which trapped air beneath it. The bell was pumped up and down, which forced air through a hole at its top and into the pipes. Sliding levers allowed or stopped the airflow through each pipe.

Those levers would come to be known as organ stops. The expression "pulling out all the stops," which means to make a great effort, comes from the fact that pulling out an organ's stops makes the instrument's sound louder.

In the sixth and seventh centuries, organs were developed using a bellows to supply the air for the pipes. A bellows is similar to a balloon; it can be filled with air, and when it is compressed, the pressurized air escapes.

A massive organ built in 950 for England's Winchester Cathedral was supplied with air from twenty-six huge bellows.

Seventy men worked the bellows while two musicians slid levers that sent air up into a set of four hundred pipes. The organ's thundering sound was said to have been heard throughout the town.

Since most organ builders were monks, organs naturally ended up in churches and cathedrals. Often they were large, impressive instruments, several stories tall and with thousands of pipes. Over the centuries, keyboards—called manuals—were added, as well as arrangements of levers and valves to control and combine the airflow through the various pipes. The addition of foot pedals allowed the organist to create even more layers of sound by playing with both of his feet and his hands.

In 1904, what was billed as the world's largest organ was installed at the St. Louis World's Fair. It sported more than ten thousand pipes and cost more than $100,000 to build. After the fair, the organ was purchased by merchant John Wanamaker, who moved it to his Philadelphia department store. From 1911 to 1930, eighteen thousand more pipes were added and the world's finest organists performed on it. Now a National Historic Landmark valued in excess of $57 million, the Wanamaker Organ still makes music.

A section of the 28,500 pipes of the Wanamaker organ, located at Macy's (formerly Wanamaker's) in Philadelphia.

YOUR BICYCLE AS MUSICAL INSTRUMENT

You may have conducted Robert Hooke's experiment of 1618 without even realizing it. Have you ever fastened a playing card to your bicycle with a clothespin, near the front or rear wheel? As you ride, the wheel's spokes vibrate the card, just as Hooke's toothed wheel moved his card. The vibrating card makes noise. The faster you ride, the faster the vibrations of the card, which results in a higher pitch—just as Hooke discovered.

Similar in principle, Hammond's tonewheels rotate in front of electromagnetic pickups that generate the tones the organ produces. See diagram at right.

Inspired by his idea for an organ, Larry began researching immediately. He learned about the physicist Herman von Helmholtz, who showed in 1864 that any ordinary musical sound is really a blend of several simpler sounds, called harmonics. The way the various simpler sounds are mixed—some louder, some softer, some moving at a higher frequency, some moving at a lower frequency—determines how our ears hear the sound. For example, a note played on a clarinet sounds different to us than a note played on a trumpet because the harmonics that make up those single notes are different.

Larry learned about Robert Hooke, an Englishman who found in 1618 that he could create musical tones with a toothed wheel and a piece of card. When the wheel was attached to a revolving shaft and the card placed against it, it made a distinctive pitch. The faster the wheel turned, the higher the pitch.

Larry asked an engineer at a firm that made loudspeakers to teach him all he knew about the technology of electronic sound reproduction, or sound that is made using electricity. Armed with his newly acquired knowledge, in 1933 Larry began experimenting in his laboratory.

He assembled what he called a tone-wheel generator. It was a wheel about the size of a silver dollar, with protruding humps on its edge that

revolved in front of a magnet that was wound with a coil of wire. Larry's synchronous motor drove the spinning wheel. Like the pickup of an electric guitar, Larry's apparatus was able to convert the changing current caused by the toothed wheel and feed it into an amplifier. There, the current was strengthened to a level where it could be emitted from a loudspeaker and heard by the human ear.

By altering the pattern of the teeth on his tone wheels, Larry was able to convert electricity into various musical notes. Still, he knew that a single, pure note could not produce the multiharmonic sounds that make up music as we know it.

Thaddeus Cahill

THE CAHILL TELHARMONIUM

In 1897, an inventor from Washington, D.C., named Thaddeus Cahill was granted a patent for his Telharmonium. Cahill was intrigued by the new technology of the telephone, which he thought would be perfect for broadcasting music to an audience.

At that time, the only way to amplify the telephone's electrical signals was to generate a bigger signal. Cahill thought that if he could do that, then place a megaphone-like cone on the telephone receiver to spread the sound, an audience would be able to hear it. He believed that hotels, restaurants, and other businesses might subscribe to his telephone broadcasts of music—as many do today to provide the background music we know as Muzak.

To create various pitches, Cahill used huge rheotomes, or notched cylinders, attached to a revolving "pitch shaft." When the notched cylinders spun on their shaft in front of a magnetic coil, electrical vibrations were generated at varying levels, which resulted in varying pitches.

The components of Cahill's Telharmonium were large and bulky, requiring many railroad cars to transport the instrument to New York City for its public debut in 1906. The invention's enormous size, plus its tendency to interfere with other telephone connections, brought a quick end to the Telharmonium. By 1915, Cahill's Telharmonic company was out of business.

It is unclear whether Larry Hammond's tone-wheel concept was inspired by the rheotome cylinders of Cahill's Telharmonium. What is certain is that both inventors had discovered how to create music from electricity.

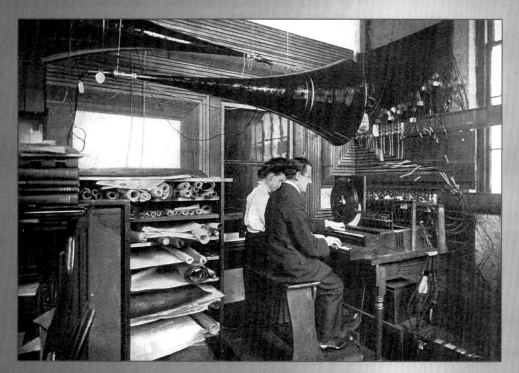

Playing the Telharmonium: Its rheotome cylinders were so huge, they were housed in a separate room.

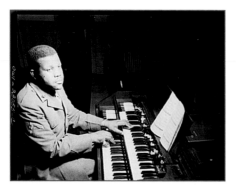

Private First Class Walker Manley, United States Marine Corps, playing a GI electric organ produced by Hammond during World War II

The FTC agreed to a side-by-side demonstration of a $75,000 pipe organ and a $2,000 Hammond organ. A group of people who could hear but not see the two instruments would try to tell the difference. So, at the chapel of the University of Chicago, fifteen college students and fifteen professional musicians were asked to distinguish between the pipe organ and Hammond's electric organ. They couldn't tell the difference ten times out of thirty. Obviously, Hammond's instrument did sound like an organ, as the judges' incorrect answers proved. A year later, the FTC ruled that Hammond could indeed call its product an organ, though it must stop its claim of an infinite number of tones.

Like other musical instrument manufacturers, Hammond's production for the public came to a halt in 1941, the year the United States entered World War II. The company's factories were immediately put into service for the war effort. Nearly 1,500 GI, or government-issue, electric organs were manufactured for U.S. sailors and soldiers on ships and bases around the world. The GI organs were played at the military's religious and entertainment functions.

The company was then told by the government to produce radio transmitters for use in airplanes. Instead of retooling his organ-making facilities, which would have had to have been reconverted to organ production after the war, Larry found an empty factory and set up the radio manufacturing there.

Ever the inventor, Larry turned his thoughts to how he might help his country win the war. Over the next several months, he and his engineers developed many systems for the military, including heat- and light-sensing devices for bomb guidance; a new type of gyroscope (an instrument that helps pilots measure their orientation in relation to the horizon); a mechanical shutter for high-speed aerial cameras; and a device for determining a plane's altitude.

After the war ended, the Hammond company easily converted back to organ-making. Many improvements were made to the Hammond instrument, including the addition of vibrato, or a regular pulsation of pitch. Vibrato helps instrumental music sound more like a human voice, making it more expressive. Post-war sales of Hammond organs to churches, theaters, radio stations, and ballparks were so great that the company purchased its own large building in Chicago.

Larry and Mildred Hammond aboard the Queen Elizabeth

Hammond Organ Company main showroom on West 57th Street in New York City, 1939

In 1949, Larry and his team introduced a more compact version of their popular organ. With its smaller size, attractive styling, and reasonable price, the Hammond spinet, or Cinderella model, became a swift seller. Families bought them for their living rooms, small churches bought them for their sanctuaries, large churches bought them for their small chapels. Over the next six years, Hammond would sell more spinets than all of the organs it had previously produced.

Soon Hammond Organ Societies sprang up, groups of friends and neighbors who gathered to learn from and entertain each other with their Hammond instruments.

In 1954, Larry's beloved wife, Mildred, mother of his two daughters, died. Larry was so sad that for six months he'd go to his office, close his door, and speak to no one.

Unable to think of anything but his loss, Larry took time away from his business to travel around Europe. He still felt empty when he returned home, so he invited friends and family on a Caribbean cruise aboard a

When the Hammond company rejected Don Leslie's new organ speaker, he started his own firm, Electro Music, to manufacture it. In 1965, Leslie sold Electro Music to the media company CBS (Columbia Broadcasting System), which made it part of its musical instruments division. In 1980, CBS sold Electro Music to … Hammond. Finally acknowledging the special Hammond organ/Leslie speaker relationship, the Hammond company decided to manufacture the cabinet itself.

rented yacht. One of his friends brought along a lovely woman named Roxana Harrison. Larry and Roxana quickly fell in love and were married.

In 1955, Hammond introduced what would become the most famous of the company's organs, the B-3. What made it so special wasn't the organ itself, but a unique speaker cabinet designed by an inventor and musician from Los Angeles, Don Leslie. Back in 1937, Leslie had bought a Hammond organ. The instrument sounded grand and impressive in the fancy Hammond showroom, but to Leslie's ears it sounded thin and flat.

A radio repairman by trade, Leslie decided to make his own speaker cabinet, one that might enhance his new organ's sound. He thought about the way pipe organs produce their rich sound, how each note is played by a pipe in a different location. The notes don't all come from a single, fixed source; the sound seems to "move." Leslie thought that putting motion into his organ's sound would give it more fullness.

Leslie experimented with rotating speakers. After three years and dozens of prototypes, the design he thought sounded best was a cabinet in which the speakers didn't move, but various sound reflectors did. Spinning, bell-shaped horns inside the cabinet transmitted sound from

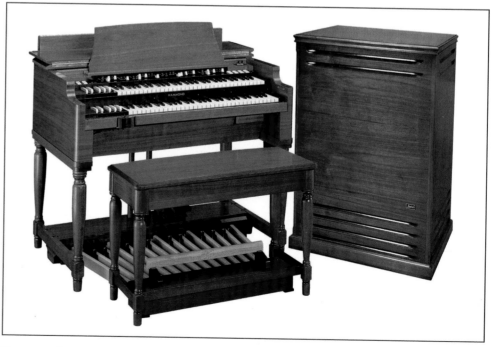

Hammond B-3, with Leslie speaker cabinet

the speakers. When connected to his Hammond, Leslie's new speaker cabinet improved the organ's sound, giving it warmth and dimension.

Leslie thought the Hammond company might be interested in his speaker cabinet. In 1940, he demonstrated his invention for a Hammond representative, who had called in thirty organists to join him. The organists were impressed; the man from Hammond was not. The company wanted no part of Leslie's new speaker innovation.

So Leslie started his own company, Electro Music, to make and sell his special speaker cabinet. When Hammond introduced its B-3 organ in 1955, musicians soon discovered that the new organ paired with an Electro Music speaker, known simply as a Leslie, produced a distinctive, versatile sound. Organists began to experiment, incorporating the B-3 into popular music like jazz and rock.

Throughout the 1960s and '70s, the B-3 became more prominent, lending its unique, Leslie-enhanced sound to hit songs like "Green Onions" by Booker T. and the MGs and "Gimme Some Lovin'" by the Spencer Davis Group. Progressive rock bands—groups that blend rock music with other styles, such as classical—including Yes and Pink Floyd, also used the B-3. Jam bands—groups like the Grateful Dead that feature long sections of free-form playing, or jams—used the B-3, as well.

Though Hammond stopped production of its B-3 in the mid-1970s, the organ's warm sound can still be heard in popular music today.

In 1960, Larry Hammond retired from the company he founded. He had invented a new kind of musical instrument, launched a new industry, and earned nearly a hundred patents for his many inventions and innovations. Larry and Roxana moved to Connecticut. On July 3, 1973, Larry died at the age of seventy-eight.

Today, Hammond organs and Leslie speakers are made by a Japanese firm called Hammond Suzuki with facilities in both the United States and Japan. Continuing in the tradition of Larry Hammond, Hammond Suzuki is committed to building the best organ possible and preserving the sound of Hammond organs and Leslie speakers for generations to come.

B-3 FOR ME — FAMOUS B-3 PLAYERS

BOOKER T. JONES: *Memphis-born Booker T. Jones was a child prodigy who played oboe, sax, trombone and piano at school and the organ at his church. While still in high school, Booker T. wrote the instrumental song "Green Onions." He formed a band with a group of friends, named it Booker T. and the MGs, and recorded his song in 1962. Featuring Booker T. on the Hammond B-3, "Green Onions" was a huge hit and launched his career as a multi-instrumentalist, songwriter, and record producer.*

KEITH EMERSON: *Considered one of the top keyboardists in rock music, England's Keith Emerson founded the progressive-rock group Emerson, Lake and Palmer in 1970. On hits like "Lucky Man," Emerson merged rock, classical, and jazz styles on his Hammond C-3, the B-3 sound-alike preferred by British musicians. Emerson is known for his theatrical performances, often playing his organ upside-down or from behind.*

Keith Emerson, one of rock music's leading keyboardists

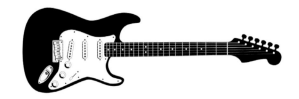

7
Fender
Electric Guitars For Everyone

I**T WAS** 1938. C**LARENCE** L**EONIDAS** F**ENDER**—L**EO,**
for short—of Los Angeles, California, was newly married. And newly unemployed.
Thanks to economic hard times, Leo had lost his accounting job. What would he do now?

Leo's hobby was electronics. As a kid, he'd built radios and even operated his own
amateur ham radio station. As a young adult, in his spare time, he built amplifiers and
public address systems for sporting events, religious gatherings, and dances. He also enjoyed
music, though he wasn't particularly musical, having taken only a few piano lessons.

Leo decided to turn his interests into a business. It was a bold move when money
was so tight. But in a small storefront in nearby Fullerton, Leo opened the Fender Radio
Service, selling and repairing electrical appliances, musical instruments, and public
address systems.

From his shop, Leo launched what would become the Fender Musical Instruments
Corporation, maker of the Stratocaster, one of the most popular and influential electric
guitars in history.

Clarence Leonidas Fender's childhood fascination with electronics would lead him to become one of the twentieth century's foremost innovators of electric instruments.

At his new store, Leo met many people in the music and electronics businesses. When the United States entered World War II, he became one of the few people in the Los Angeles area who sold and repaired instruments. Leo wasn't eligible for military service because he had lost his right eye due to a childhood illness.

One day, professional violinist and lap-steel guitarist Clayton Orr Kauffman, known as Doc, brought an amplifier to the Fender Radio Service for repair. As Leo and Doc chatted, they discovered that they both had been tinkering with ideas for an electric guitar. They decided to work together.

In 1943, Leo and Doc built a test guitar in which to install their experimental pickup designs. The guitar wasn't hollow like the electrified Spanish-style instruments other guitar makers were producing. Its body was made from a single slab of wood.

Leo and Doc also designed a device for changing the records on a phonograph. To make and sell their invention, they formed a business partnership, Kauffman & Fender. In 1945, with the money they made from selling their record-changer at Leo's store, the pair began manufacturing electric lap-steel guitars and small amplifiers. They set up their workshop in a little tin shack behind the Fender Radio Service store.

Leo would work late into the night on his electronics, happily designing and assembling his guitars and amplifiers. He loved tinkering and testing and analyzing. But Doc preferred to put in a day's work, then go home to spend time with his family. And with the Depression still fresh in his mind, Doc worried about the business failing. So in 1946, he left the partnership.

Now Leo had both the new guitar company—which he renamed the Fender Electric Instrument Co.—and his Fender Radio Service store to take care of.

Leo bought parts for his shop from the Radio and Television Equipment Co., also known as Radio-Tel. With his hands full running two businesses on his own, Leo asked Radio-Tel to sell Fender Electric Instrument products to musical equipment dealers. Business was slow but steady, and Leo was able to move his lap-steel and amp-making business to a larger property nearby.

With World War II finally over, there was a sense of optimism in the United States. Manufacturers began to mass-produce their products—many

Fender offices, ca. 1940s

FEEDBACK

Guitar feedback is a high, squealing noise that occurs because of a sound loop between the guitar's pickup and its amplifier's loudspeaker. The guitar's amplified sound coming from the loudspeaker is received again by the pickup near the strings, reamplified, and rebroadcast through the loudspeaker.

With a hollow-body guitar, feedback can be a particular problem. At a high volume, the instrument's sound from the loudspeaker can cause the hollow-body guitar to vibrate. The guitar's pickups receive the vibrations, they're reamplified, and then rebroadcast through the loudspeaker, causing feedback.

using car maker Henry Ford's assembly-line process—and people were eager to buy them. As Fender's lap-steels became more and more popular on the West Coast, Leo started to think about how he could mass-produce his guitars and amps instead of making them one at a time by hand.

Leo also began to ponder branching out from the lap-steel. Many local musicians played the electric Spanish-style guitars. But those instruments often suffered feedback problems because of their hollow bodies. Leo remembered the solid-body guitar he and Doc Kauffman had made to test their electric guitar pickups. He wondered if guitarists would be interested in a solid-body instrument.

Actually, several versions of a solid-body electric Spanish guitar had already been developed, such as well-known guitarist Les Paul's "log" of around 1940, later commercially produced by Gibson. Some had even made it to market—like Rickenbacker's nearly solid Model B of 1935, made of plasticlike Bakelite—though they'd never caught on. And Leo himself was already building solid-body lap-steel guitars.

1951 Nocaster

NOCASTERS

To identify its various instruments, Fender would place a decal with the company's logo and the name of the model on the guitar's headstock, next to the tuning pegs. When Fender dropped the Broadcaster name at Gretsch's request, the company was left with scores of Broadcaster decals. Instead of throwing the stickers away, the Broadcaster name was snipped from the decal, leaving just the logo. Fender guitars with these "no-name" decals are known today as Nocasters.

It's not clear whether Leo was aware of any of the other solid-body Spanish guitars. What is known is that he began testing his own prototypes, giving them to local musicians to try. He asked them what they liked and didn't like about his solid-body instruments. Using their answers as his guide, he tweaked and refined his new guitar design. He created a shape with a curved cutout, called a cutaway, where the neck met the body. This made the guitar lighter and gave the player easier access to the higher notes on the guitar's neck.

Fifteen miles away in the city of Downey, Paul Bigsby, a machinist with the Crocker Motorcycle Company, was also busy in his workshop. Country music star Merle Travis, a friend of Bigsby's, had asked Bigsby to build him a solid-body guitar from a drawing Travis had made. In 1948, Travis debuted the Bigsby guitar, playing it at live performances and on the radio. The unique instrument, with its slim body and six tuning pegs on one side of the headstock, drew a lot of attention.

Leo was acquainted with both Travis and Bigsby and had seen their new guitar, but he continued improving his own solid-body design. He thought he could make an instrument that could stand up to rough treatment, one that was easy to make and repair, yet still produced an excellent sound.

By April 1950, Leo was ready to sell his unusual new guitar, which Radio-Tel general manager Don Randall named the Esquire. Radio-Tel salesmen were given samples, and a sales team was sent to an important musical instrument industry trade show in July. "I just got laughed out of the place," Randall later told guitar historian Tony Bacon. "Our new guitar was called everything from a canoe paddle to the snow shovel."

The Esquire also had a few problems. The detachable neck, which was easy to

1950 Esquire

remove for repair, was prone to bending, so Leo added a truss rod, or adjustable steel rod, for reinforcement. And a flaw in the pickup's design caused it to stop working sometimes. Leo fixed that, plus added another pickup, for a total of two on every guitar.

Leo was more interested in creating guitars than naming them, so Radio-Tel's Randall came up with a new name for the instrument: the Broadcaster. The Fender Broadcaster went on sale in January 1951. One hundred and fifty-two guitars were sold until Gretsch, a New York-based instrument manufacturer, put an end to the Broadcaster name. Gretsch had been using the name Broadkaster on its banjos and drum products since 1937. The company asked Fender to stop calling its guitar the Broadcaster. Leo agreed.

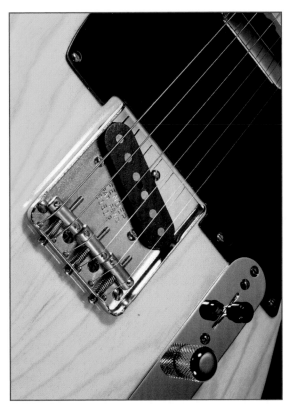

First called the Broadcaster, the Telecaster is a versatile guitar played by country, rock, and jazz musicians.

Again, Randall came up with a new name: the Telecaster. Television was a relatively new phenomenon, becoming widely popular after World War II. And Leo's store had been among the first to sell televisions in the Los Angeles area.

With its no-frills construction—a solid slab of ash for a body and a separate, screwed-on, maple neck—and rugged dependability, the Telecaster quickly became a favorite of working musicians. This was no fancy, flashy guitar. The Telecaster was a workhorse that could take the punishment of nightclub gigs and cross-country concert tours. It was easy to repair and had its own distinctively bright sound.

In 1951, Leo took all of the things that made the Telecaster great and incorporated them into his Precision Bass, the first commercially successful, solid-body electric bass guitar. Unlike an acoustic bass, Leo's instrument had frets along its neck so it could be played with precision.

With sales of his three solid-body electric

1952 Telecaster

EARLY TELECASTER PLAYERS
JIMMY BRYANT:

When guitarist Jimmy Bryant teamed up with pedal-steel guitarist Speedy West, they became one of the most popular and one of the best instrumental teams in country music. Bryant was such a great player that he was often billed as "The Fastest Guitar in the Country." Bryant was one of the first country guitarists to use Leo Fender's new Telecaster.

MUDDY WATERS:

Mississippi-born Muddy Waters is considered one of the greatest blues artists of all time. After moving to Chicago in the 1940s, Waters played in blues clubs and began recording his songs. His loud, electrified blues style earned him new audiences when he performed in England in the late 1950s, at the prestigious Newport Jazz Festival in Rhode Island in 1960, and with rock group The Band in 1976. British rockers the Rolling Stones took their name from Waters's 1950 signature tune "Rollin' Stone."

guitars flourishing, as well as his still-brisk business in electric steel guitars and amplifiers, Leo purchased a trio of new buildings in Fullerton in 1953. He wanted to expand his product line with another new solid-body electric guitar.

So Leo listened again to what guitar players said they wanted. Some guitarists complained that the Telecaster body's hard edge was uncomfortable. Others wanted more pickups to capture the different tones of the strings at the neck, middle, and bridge. Still others wished for a way to create vibrato, a bending of pitch.

Leo went to work. Taking the basic idea of the Telecaster, he rounded the body's edges to make playing it more comfortable. Instead of one cutaway, he used two, like his Precision Bass. Instead of two pickups, he used three, and installed controls that allowed the guitarist to switch between and blend the sounds from each pickup. And he added a built-in vibrato unit, called a tremolo arm or tremolo bar.

Fender sales manager Don Randall took one look at the curvy guitar with its shiny knobs and gleaming chrome tremolo bar and thought of rockets, outer space, and the stratosphere. At the time, 1954, the U.S. military's new B-52 bomber jet was named the Stratofortress, while automobile maker Pontiac was launching its Strato-Streak car. Randall christened Leo's new guitar the Stratocaster.

Though the shapely new Stratocaster looked and sounded like no other guitar on the market, it was hardly a runaway success at first. In Fender's first two years of Stratocaster production, the company sold fewer of the new guitars than its Esquires and Telecasters.

A teenage guitarist named James Burton had something to do with the Telecaster's popularity. Almost every week in the late 1950s he was seen on television with his Tele, playing behind teen singing idol Ricky Nelson in the *Adventures of Ozzie & Harriet* show.

As the rock-and-roll phenomenon quickly gathered steam, though, other high-profile artists made the Fender Stratocaster their first choice of electric guitar. It wouldn't be long before the Stratocaster came to define the look and sound of American rock music.

By 1958, Leo had introduced other variations on his easy-to-build, easy-to-repair, bright-sounding solid-body electrics. To capitalize on the music stores' marketing tactic of offering lessons on the instruments they sold,

Fender Precision Bass guitars

BASS GUITAR

Bass guitars look similar to electric guitars, except their bodies are a bit larger, they have four strings instead of six, and they're typically played with the fingers instead of a pick. The bass guitar provides the lower notes of a song and is often used rhythmically, helping to create and keep the song's beat.

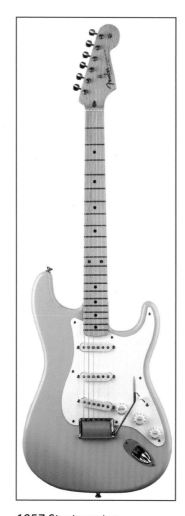

1957 Stratocaster

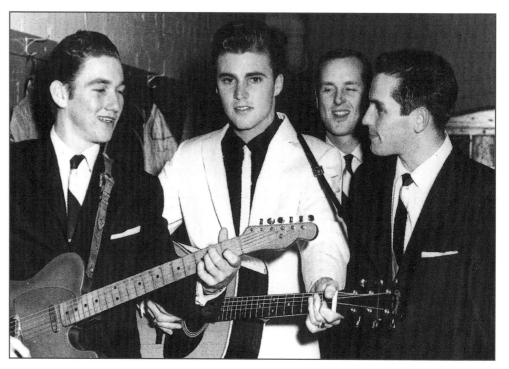

James Burton, left, and Ricky Nelson, center

1962 Jazzmaster

Fender created smaller, "student" electrics. And to compete with the fancier, showier guitars of rivals like Gibson, Leo came up with the Jazzmaster, with its unusual offset waist shape and luxurious rosewood fingerboard. To complement the Jazzmaster, Leo introduced the Jazz Bass in 1960. It had a narrower neck than the Precision model, which Leo thought would be more appealing to jazz players.

Leo had also bought a stylish advertising campaign. In 1957, he'd hired Bob Perine, a young graphic designer, who created a

series of memorable Fender ads that ran for many years. Each ad featured someone with a Fender guitar or amp in an unusual setting—surfing, skydiving, piloting a plane, driving a tank—and the line "You won't part with yours either." Perine also designed the distinctive Fender logo, based on Leo's signature, as well as eye-catching catalogs for Fender products. The ads, logo, and catalogs helped establish the company's brand identity, which was increasingly important as American advertising became more sophisticated.

Sales for Fender's top-of-the-line guitar, the Jazzmaster, were disappointing. But Leo didn't give up on his idea of a high-end instrument. In 1962, he introduced the Jaguar, similar in shape to the Jazzmaster but with more complex controls. Leo also rolled out a low-end guitar in 1964, the Mustang, another student model.

Still, it was Leo's Telecasters and Stratocasters that flew off the music store shelves. Guitar-fueled rock had exploded on both sides of the Atlantic, and musicians around the world clamored for Fender's affordable, reliable, distinctive-sounding guitars. By the end of 1964, Fender operations in southern California were housed in twenty-nine buildings and staffed by

Graphic designer Bob Perine created many of Fender's eye-catching ads, such as this one from the early 1960s.

WHAT A WHAMMY!

A tremolo arm is a lever attached to the bridge and tailpiece of the guitar that allows the player to change the tension of the strings, and therefore their pitch.

Paul Bigsby designed such a device before Leo came up with his tremolo arm. But Bigsby's popular tremolo was mounted on top of the guitar's body, not within it, and was prone to malfunctioning when the arm was lifted too much. Bigsby tremolos are still manufactured and used today, though.

In the 1960s, the tremolo arm became known as the whammy bar. The name stuck. Now most guitarists and their fans refer to the string-bending device as the whammy bar.

1957 Stratocaster, with whammy bar

Buddy Holly was the unlikeliest of rock-and-roll stars. He was a skinny kid with glasses from Lubbock, Texas, who played the newfangled Stratocaster guitar. But he played it so well, and his hillbilly-meets-rhythm-'n'-blues tunes were so irresistible, that Holly became one of the pioneers of the rock-and-roll genre. His several TV appearances with his Stratocaster helped popularize the instrument.

Unfortunately, Holly's career was brief; he died in a 1959 plane crash at age twenty-two. His timeless songs, like "That'll Be the Day" and "Peggy Sue," have continued to inspire and influence generations of rock musicians, including the Beatles and the Rolling Stones.

Ritchie Valens was another rock-and-roll trailblazer who preferred the Stratocaster, and was the genre's first Latino star. Influenced by Mexican folk songs and the singing cowboys in Western movies, Valens is best known for his hits "Donna" and "La Bamba." Sadly, Valens died in the same plane crash that killed Buddy Holly. He was only seventeen.

Ritchie Valens

six hundred employees who churned out an amazing 1,500 instruments a week.

Leo should have been happy, but he was miserable. For years, he'd been suffering with a viral infection that sapped his energy. He wasn't sure he was healthy enough to continue guiding his company's wildfire success. So in January 1965, he sold Fender to media giant CBS for a record-breaking $13 million. CBS would later acquire other musical instrument–related companies, including Steinway and Leslie.

After Leo sold his company to CBS, he stayed on for five years as a special consultant. His health improved and in the early 1970s he launched Music Man, another firm that produced guitars, basses, and amplifiers. Later, he founded G&L Musical Products, which also manufactured guitars. Throughout the rest of his life, Leo continued to improve upon his basic guitar designs. After a series of strokes, Leo Fender, electric guitar pioneer, died in 1991. He was eighty-two.

By the mid-1970s, there were rumblings in the guitar world that Fender quality was not what it once was. Many high-profile musicians were seen playing older Fender instruments, adding to the perception that the newer Fender guitars were inferior. The company's experimentation with cheap foreign parts and manufacturing didn't help matters either.

Fender Western custom guitar

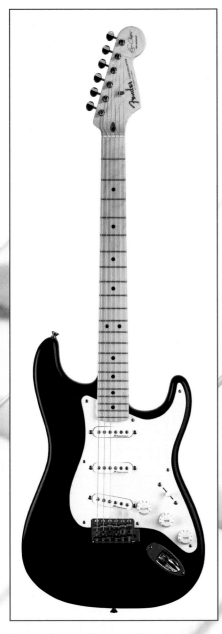

BROWNIE AND BLACKIE, FAMOUS STRATS

In 1967, British guitar hero Eric Clapton of Cream switched from playing Gibson guitars to a 1956 Stratocaster he nicknamed Brownie. He used the Strat to make his wildly popular 1970 album, Layla and Other Assorted Love Songs, with his new band, Derek and the Dominoes.

Clapton loved Brownie's sound, feel, and durability so much that on a visit to Nashville, Tennessee, he bought an entire rack of second-hand 1950s Stratocasters at a music store. He gave three of them to famous guitarist friends who also appreciated Strats: Steve Winwood of Traffic, George Harrison of the Beatles, and Pete Townshend of the Who. Clapton took the rest of the old guitars apart, shuffled the parts, and reassembled a black-bodied Stratocaster that would become his most famous guitar, Blackie. Clapton would play Blackie for years.

In the 1980s, when Blackie finally wore out, Clapton and the Fender company worked together to build the Eric Clapton Signature guitar, a Blackie replica that became a part of the company's product line.

At a 1999 charity auction, Brownie sold for an incredible $450,000. In 2004, Blackie fetched $959,500 at another charity auction, making it the most expensive guitar in history.

Fender's Eric Clapton Signature guitar, a replica of Blackie

One of the reasons for the notion that older Fender guitars were better was a guitarist from Seattle, Washington, named Jimi Hendrix. Considered by many to be the finest guitarist in history, Hendrix began playing Stratocasters in 1966 and used them almost exclusively until his death in 1970.

On stage and in the recording studio, Hendrix explored and experimented with the full range of sounds the electric guitar could produce. He was a master of incorporating feedback into his highly amplified, blues-fueled rock music. He was also known for his showy wardrobe and impressive array of tricks: he could play guitar with his teeth, behind his back, and between his legs, and made constant use of the whammy bar.

Hendrix's influential sound and style paved the way for hard rock and heavy metal.

This bronze statue of Jimi Hendrix is located in Seattle, Washington, his hometown.

By the dawn of the 1980s, it seemed to many that Fender was more concerned with the bottom line than producing quality products. Sales were in decline and the company was losing money.

In 1985, a group of Fender employees and investors purchased the company from CBS for $12.5 million. The price was $500,000 less than what CBS had paid for the firm back in 1965. Quality and craftsmanship took center stage.

Today, Fender is one of the leading guitar makers in the world. The solid-body electrics—the Telecaster, the Stratocaster—pioneered by Leo Fender in the 1950s are still the company's mainstay, though they now come in many variations and are loaded with modern features.

After more than five decades, Leo's groundbreaking designs—the perfect pairing of function and form—remain icons of American popular culture worldwide.

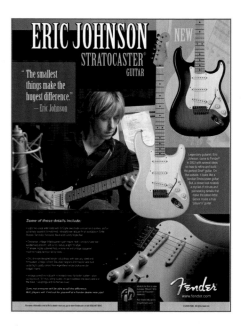

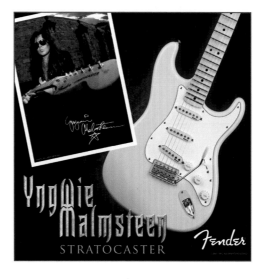

The electric guitars created by Leo Fender in the 1950s are still popular today.

Leo Fender

JOHN MAYER STRATOCASTER

8
Moog
Sculpting Electronic Sound

To Robert Arthur Moog, the basement was his very own playground.

After his homework was done and his piano lesson practiced, the shy teen would descend the stairs to a wonderland of tools, gadgets, and electrical gizmos.

Bob's dad, an engineer with the local power company, had equipped the family's Queens, New York, basement as a workshop for his own hobby, amateur ham radio. After school, Bob would often stop by "Radio Row," an area with many electronics shops, to buy parts. Mr. Moog (rhymes with *vogue*) would bring scraps of metal home from work. Together, Bob and his dad would tinker in the Moog basement workshop for hours, building radios and other projects. Bob was especially interested in how sound could be produced by electronic means.

In 1949, when he was fifteen, Bob built his first theremin, an unusual musical instrument that is played by moving your hands near two antennas The electrical interaction between the antennas and your hands produces the theremin's eerie, wailing

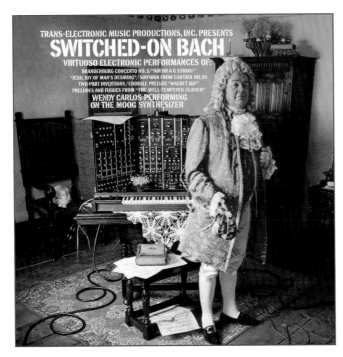

Switched-On-Bach, *released in 1968, sold more than a million copies, one of the first classical albums to do so. The album brought classical music to the electronic synthesizer, and Bach suddenly was hip.*

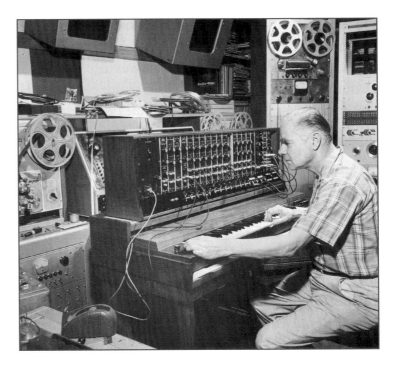

appealing to pop, classical, and experimental electronic music listeners alike. It was the first classical recording to sell more than a million copies. It still sells well today. *Switched-On Bach*, through its extraordinary music and its distinctive cover photo featuring a Moog system, introduced the mainstream public to Bob's instrument.

By this time, Bob had decided on a name for his creation: the synthesizer. To synthesize something means to build a whole from various parts. Bob thought of his modules and the way they were able to sculpt sounds as parts that worked together to create a whole sound.

Thanks to *Switched-On Bach*, the Moog synthesizer was now known nearly worldwide. By the early 1970s, the word *Moog* came to mean any synthesizer, even though there were similar instruments by other manufacturers available. It was an amazing example of product branding, or making people aware of your brand above all others.

Switched-On Bach also proved that there was a tremendous market for music made with a synthesizer. Record companies scrambled to release their own Moog-based albums, including *Switched-On Santa!*, *Switched-On Rock*, *Chopin à la Moog*, and *Moog Plays the Beatles*. None of them

Wendy Carlos, composer and musician, helped to popularize the Moog synthesizer.

The Moog synthesizer came to the attention of the music world in 1967 when it was demonstrated at the Monterey International Pop Festival, Monterey, California. Among the first groups to feature the electronic musical instrument were the Doors, the Byrds, and the Rolling Stones. Soon people began asking, "What's a synthesizer?" Here Bob Moog seems to be thinking of the best way to answer the question.

were nearly as artful, or as successful, as Wendy Carlos's original.

The popularity of *Switched-On Bach* also created a tremendous demand for Moog products. Now every professional musician seemed to want his or her own Moog synthesizer, despite its expensive price. Bob hired more than forty employees for his Trumansburg facility, which began to function more as a factory than a workshop.

Progressive-rock artists, with their interest in pushing the boundaries of rock music, were especially fascinated by the Moog. Keith Emerson of the British group Emerson, Lake & Palmer was among the first to take his "Monster Moog" on concert tours with him, as well as his Hammond C-3 organ. In the hands of Emerson, along with other progressive-rock keyboardists like Rick Wakeman of Yes, the synthesizer became an instrument as worthy of the solo spotlight as the guitar.

Carting around the enormous Moog synthesizer modules was not terribly convenient for performing musicians. A smaller, more portable synthesizer would be useful, thought Bill Hemsath, an engineer whom Bob had hired after *Switched-On Bach*. A Moog that had its "patches," or combinations of connected modules, built inside it would be an

THE MONKEES, THE STONES, AND THE MOOG

One of the first pop musicians to own a Moog was Micky Dolenz of the Monkees. The Monkees were an American pop-rock quartet formed in 1965 for the TV show of the same name. Two songs on the group's 1967 album Pisces, Aquarius, Capricorn & Jones Ltd. *featured the Moog synthesizer.*

In 1968, British rockers the Rolling Stones worked out a deal with Bob for one of his modular synthesizers. Though Stones singer Mick Jagger is reported to have considered using the Moog as his onstage instrument, the synthesizer appeared instead only as a prop in the Rolling Stones' 1970 film, Performance.

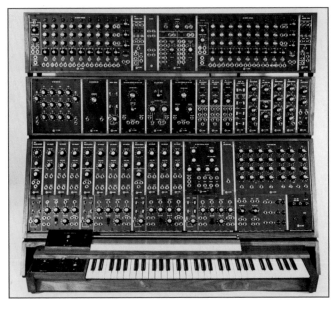

1968 Moog synthesizer

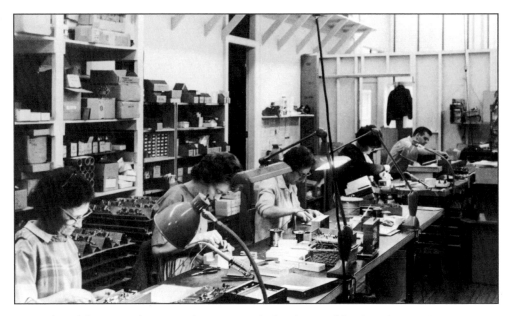

Moog hired forty employees to keep up with the demand for his electronic instrument.

improvement, too, Hemsath mused. All previous Moogs used special cords to hook the modules together, like an old-fashioned telephone switchboard.

Hemsath began spending his lunch hours walking the Moog "graveyard," the attic above R. A. Moog, Inc. in Trumansburg. Here all of the scraps from the operation were stored—broken cases, extra keyboards, leftover electronic components. In just two months, he assembled from the Moog garbage a miniature synthesizer with all of its parts wired together inside a single console. It was housed in a unique flip-up case that could be carried like a suitcase when not in use. The Minimoog was born.

Moog unveiled its new portable synthesizer in 1970. It was a runaway hit. From 1970 to 1983, more than thirteen thousand units were sold.

Bob, though a brilliant inventor, was not the best businessman. The Moog company had accumulated tremendous debt in its brief existence. So, in 1971, he was forced to sell his company, which was renamed Moog Music. Bob stayed on with the company until 1977. Moog Music's parent company fell into bankruptcy in 1986, and Moog Music stopped production altogether in 1993.

By the late 1970s, more and more manufacturers around the world had

1971 Minimoog

begun producing synthesizers. By the 1980s, they were commonly heard in popular music, from radio hits to movie and television soundtracks. Many people liked synthesizers because they could imitate other instruments, in addition to making their own unique sounds. Synthesizers became even more versatile and user friendly when digital, or computer, technology was added to them in the early 1980s. Now, much of what we hear every day—cell phones, computers, beepers—is synthesized sound, which evolved directly from Bob's invention.

When Bob left his namesake company, he headed for the mountains of Asheville, North Carolina. There he launched a new company in 1978 to consult with other music technology companies and to manufacture his first love, the theremin. Because Bob had sold the rights to the Moog name with his former company, he named his new business Big Briar, Inc.

After a long legal battle, in 2002 Bob finally won the rights to use the Moog Music name. He was thrilled. Under his direction, Moog Music began manufacturing an updated version of the popular Minimoog, called the Minimoog Voyager, plus other electronic music products.

YES, IT'S RICK WAKEMAN

A classically trained pianist, Rick Wakeman is best known as the keyboardist for the British progressive-rock group Yes. He bought his first electronic keyboard, a Minimoog, for half price from a British actor who couldn't figure out how to make it work. Wakeman has said that the Minimoog "absolutely changed the face of music" because "for the first time you could go on [stage] and give the guitarist a run for his money."

Since the introduction of the synthesizer, some forms of popular music have relied heavily, and almost exclusively, on its distinctive sounds.

Many hits of the disco genre, a dance-oriented music that emerged in the 1970s, featured electronic percussion and synthesized melodies. Donna Summer's 1977 hit "I Feel Love" used a completely synthesized backing track featuring a modular Moog.

New Wave, which came from the punk rock movement of the late seventies and early eighties, also incorporated synthesizers into its experimental pop music. Groups like Duran Duran, Depeche Mode, the Fixx, and Eurythmics used layers of synthesizer sounds to craft their mood-creating songs.

The distinctive bass sound heard in many hip-hop songs is often the Moog synthesizer. Hip-hop is a musical style that features rhythmic vocals, called rap, over backing beats. Hip-hop producers like Fred Wreck, who works with Snoop Dogg and Puffy Combs, and Printz Board, musical director for the Black Eyed Peas, rely on Moog instruments.

Most recently, the term electronica *has been used to define a variety of music made with synthesizers and other electronic instruments, from dance styles like that of Moby and Orbital to the dreamy New Age sounds of Jean Michel Jarre, Deep Forest, and Enya.*

Minimoog Voyager, 2002

Sadly, in April 2005, Bob was diagnosed with a brain tumor. He died on August 21, 2005, in Asheville. He was seventy-one.

To honor Bob's trailblazing life and legacy, his family established the Bob Moog Memorial Foundation, a nonprofit organization devoted to the advancement of electronic music, in part through construction of a Bob Moog Museum in Asheville.

Today, Moog Music, under the leadership of staff Bob hired himself, continues to handcraft the instruments that he pioneered and cherished.

Part of Bob Moog's patent for "electronic high-pass and low-pass filters employing the base to emitter diode resistance of bi-polar transistors." Aren't you glad he called it a synthesizer?

Moog, Moog Music, and Minimoog are registered trademarks of Moog Music, Inc.

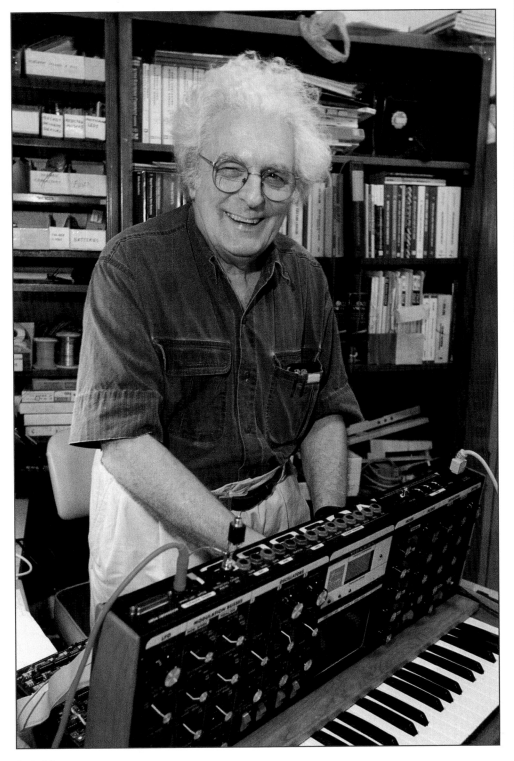

Bob Moog

Armonica

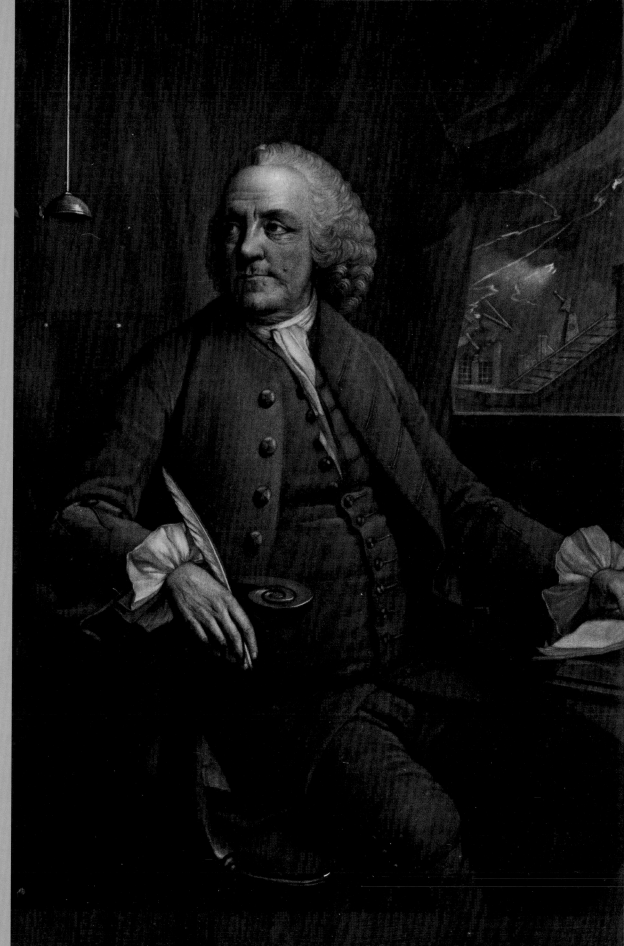

A Closing Note

You've just met some of the greatest names in American instrument making. But did you know that American musical innovation dates as far back as colonial times?

Benjamin Franklin, one of the founding fathers of the United States of America, was fascinated by music. He played several instruments, liked to attend concerts, and even composed music. Since he was also a scientist and inventor, he was especially interested in the science of music.

In the mid-1700s, while Franklin was in London representing colonial America, he saw a performer play music on a set of water-filled wine glasses. Each glass held a different amount of water. When the musician ran a wet finger around the rim, the friction caused each glass to "sing" at a certain pitch.

Though musical water glasses date back to the Renaissance, Franklin was so intrigued he decided to build a new instrument based on this idea. He worked with a glassblower in London to create a series of bowls in various sizes. An iron rod was run through a hole in the center of each bowl. Then the rod was attached to a wheel. A pedal turned the wheel, which turned the rod, which spun the bowls. When Franklin touched his moistened finger to the spinning bowls, they made beautiful sounds.

Franklin called his invention, completed in 1761, the armonica. Its name comes from the Italian word for harmony. It became very popular in the late 1700s. Composers such as Mozart and Beethoven wrote music for the armonica. Franklin often brought an armonica along on his travels. By the time of his death in 1790, more than 5,000 armonicas had been made.

Benjamin Franklin took an old musical idea and, literally, gave it a fresh spin, paving the way for other instrument innovators in America, like those you've met here. With new ideas, grand dreams, and a whole lot of hard work, these dynamic leaders helped to shape the way music is played and heard today.

Bravo!

NOTES

CHAPTER ONE: ZILDJIAN
As Armand, who passed away in 2002, once said, "A Zildjian cymbal just zings." Cohan, Jon. *Zildjian: A History of the Legendary Cymbal Makers* (Wisconsin: Hal Leonard, 1999), 124.

CHAPER FOUR: MARTIN
The Violin Makers Guild was trying to stop cabinetmakers from producing musical instruments, claiming that only members of the Violin Makers Guild were "artists … of a cultured taste" capable of crafting fine musical instruments. Cabinetmakers, the Violin Makers Guild announced, were "nothing more than mechanics" who should stick to building furniture. "Who is so stupid that he cannot see at a glance that a grandfather's armchair or a stool is no guitar?" the Violin Makers Guild asked. *Historical Review of the Violin Makers Guild of Mark Neukirchen, 1927*, as quoted in Johnston, Richard, and Dick Boak. *Martin Guitars: A History* (Milwaukee: Hal Leonard, 2008), 23.

A respected instrument salesman publicly reminded the violin makers that while in Vienna, Christian Friedrich Martin had "produced guitars, which in point of quality and appearance left nothing to be desired and which marked him as a distinguished craftsman." *Historical Review of the Violin Makers Guild of Mark Neukirchen, 1927*, as quoted in Johnston, Richard, and Dick Boak. *Martin Guitars: A History* (Milwaukee: Hal Leonard, 2008), 24.

CHAPTER SIX: HAMMOND
Larry's friends at Cornell asked him what he was going to do next. "I'm going to be an independent inventor," he told them. There was no such thing, his friends replied. An inventor goes to work for somebody else's company, they told him. An inventor researches and invents things for a corporation. Larry disagreed. "The fact that you don't know any independent inventor," he said to his friends, "doesn't mean that there couldn't be one." Barry, Stuyvesant. *Hammond as in Organ: The Laurens Hammond Story*. Unpublished typescript based on series of interviews with Laurens Hammond, circa 1970, chapter 6.

CHAPTER EIGHT: MOOG
Wakeman has said that the Minimoog "absolutely changed the face of music" because "for the first time you could go on [stage] and give the guitarist a run for his money." Fjellestad, Hans, dir. *Moog: A Documentary Film*. Plexifilm, 2005.

SOURCES

Books:

Bacon, Tony. *50 Years of the Gibson Les Paul: Half a Century of the Greatest Electric Guitars*. San Francisco: Backbeat Books, 2002.

Bacon, Tony. *The Fender Electric Guitar Book: A Complete History of Fender Instruments*. San Francisco: Backbeat Books, 2007.

Bacon, Tony. *Six Decades of the Fender Telecaster*. San Francisco: Backbeat Books, 2005.

Carter, Walter. *The Martin Book: A Complete History of Martin Guitars*. San Francisco: Backbeat Books, 2006.

Chapin, Miles. *88 Keys: The Making of a Steinway Piano*. New York: Random House, 1997.

Cohan, Jon. *Zildjian: A History of the Legendary Cymbal Makers*. Milwaukee: Hal Leonard, 1999.

Johnston, Richard, and Dick Boak. *Martin Guitars: A History*. Milwaukee: Hal Leonard, 2008.

Lieberman, Richard K. *Steinway and Sons*. New Haven, CT: Yale University Press, 1997.

Ludwig, William F. *My Life at the Drums*. Chicago: Ludwig Industries, 1972.

Ludwig, William F. and Rob Cook, ed. *The Making of a Drum Company: The Autobiography of William F. Ludwig, II*. Alma, MI: Rebeats, 2001.

Pinch, Trevor and Frank Trocco. *Analog Days: The Invention and Impact of the Moog Synthesizer*. Cambridge: Harvard University Press, 2002.

Pinksterboer, Hugo. *The Cymbal Book*. Milwaukee: Hal Leonard, 1992.

Ratcliffe, Ronald. *Steinway*. San Francisco: Chronicle, 2002.

Schmidt, Paul William. *History of the Ludwig Drum Company*. Fullerton, CA: Centerstream, 1991.

Vail, Mark. *The Hammond Organ: Beauty in the B*. San Francisco: Backbeat Books, 2002.

Vail, Mark, ed. *Keyboard Presents Vintage Synthesizers*. San Francisco: Backbeat Books, 2000.

Wheeler, Tom. *The Stratocaster Chronicles: Celebrating 50 Years of the Fender Strat*. Milwaukee: Hal Leonard, 2004.

Additional Sources

Banks, Margaret Downie. "A Brief History of the Conn Company (1874–Present)," excerpted and updated in 1997 from *Elkhart's Brass Roots: An Exhibition to Commemorate the 150th Anniversary of C. G. Conn's Birth and the 120th Anniversary of the Conn Company*. Vermillion, SD: The Shrine to Music Museum, 1994.

Banks, Margaret Downie. "The C. G. Conn Company: A Retrospective," *CIMCIM Newsletter*, XIV, 1989.

Banks, Margaret Downie. "Box of Condensed Harmonies: Conn's Wonder Portable Folding Reed Organ," *Reed Organ Society Bulletin*, Vol. XVI, No. 2, Summer1997.

Barry, Stuyvesant. *Hammond as in Organ: The Laurens Hammond Story*. Unpublished typescript based on series of interviews with Laurens Hammond, circa 1970.

"Col. C. G. Conn, 86, Is Dead; Body Will Be Brought to Elkhart," *The Elkhart Truth*, January 6, 1931.

"Fifty Years of Musical Excellence." Hammond Organ Company brochure, 1984.

Fjellestad, Hans, dir. *Moog: A Documentary Film*. Plexifilm, 2005.

Hill, Matthew. "George Breed and his Electrified Guitar of 1890." Paper presented at the joint Galpin Society/CIMCIM/American Musical Instrument Society meeting at the National Music Museum, Vermillion, SD, 2006.

Schwartz, Richard I. *The Cornet Compendium: The History and Development of the Nineteenth-Century Cornet*. Self-published at www.angelfire.com/music2/thecornetcompendium/. 2002.

Web sites

(Active at time of publication)

C. G. Conn, *www.cgconn.com*
The Conn Loyalist, *www.xs4all.nl/~cderksen*
Fender, *www.fender.com*
Friends of the Wanamaker Organ, *www.wanamakerorgan.com*
Hammond, *www.hammondorganco.com*
Ludwig, *www.ludwig-drums.com*
Martin, *www.martinguitar.com*
Moog Archives, *www.moogarchives.com*
Moog Music, *www.moogmusic.com*
Steinway, *www.steinway.com*
Vistalites, *www.vistalites.com*
Zildjian, *www.zildjian.com*

Photo Credits

Jacket: Courtesy Fender Musical Instruments Corporation

Jimi King, Juke Box, Big Stock Photography: 1;
Angela Cable, background gold foil, Big Stock Photography: 1, 2, 3, 4, 5

Chapter One: All pictures courtesy of Avedis Zildjian Company. Additional pictures: Aleksey Klementiev, Big Stock Photography: 7; Library of Congress: 12 (left), 13, 14; Nikolay Okhitin, brass background, Big Stock Photography: 6, 13, 14, 19, 20; Susan VanHecke: 19 (left)

Chapter Two: All pictures courtesy of Steinway & Sons. Additional pictures: Peter Baxter, Big Stock Photography: 23; Anton Gvozdikov, piano keyboard, Big Stock Photography: 28–29, 33; Tom Hipps, U.S. Army (army.mil/images): 41; Library of Congress: 36 (left), 37; Grant O'Brien, www.claviantica.com: 24 (left); Vitaliy Pakhnyushchyy, wood background, Big Stock Photography: 25 (left), 31, 33 (left), 33; 35 (right)

Chapter Three: All pictures courtesy of Conn-Selmer. Additional pictures: Angela Cable, background gold foil, Big Stock Photography: 40, 44, 46; courtesy of Nick DeCarlis, www.PocketCornets.com: 40 (right), 47; Vitali Dyatchenko, electric guitar strings, Big Stock Photography: 52, 56; German Federal Archive, Bundesarchiv, Bild 102-10143 / Unknown / CC-BY-SA. Wikimedia Commons/Creative Commons: 48 (bottom); Michele Goglio, Big Stock Photography: 41; National Music Museum, The University of South Dakota: 42 (top), 45, 46 (top right), 48 (left), 49 (right); Photographer's Mate 1st Class Alan Warner, United States Navy: 53

INDEX